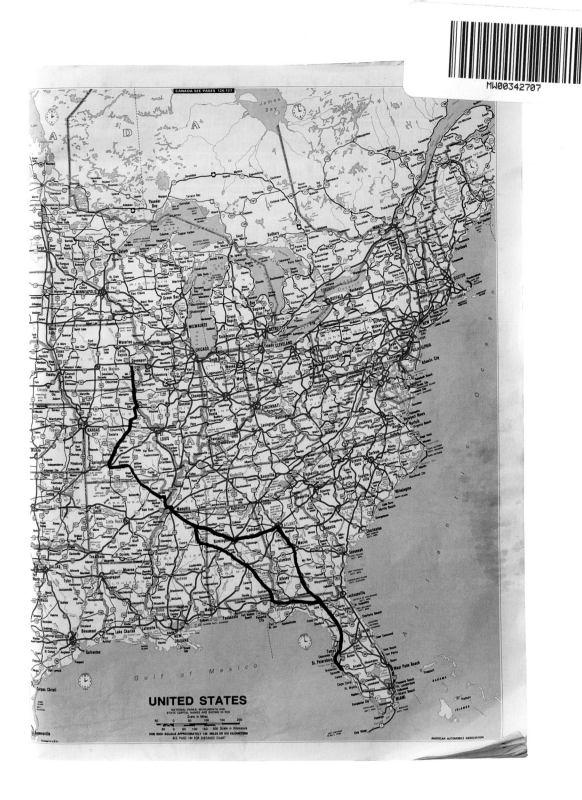

For Mom and Dad

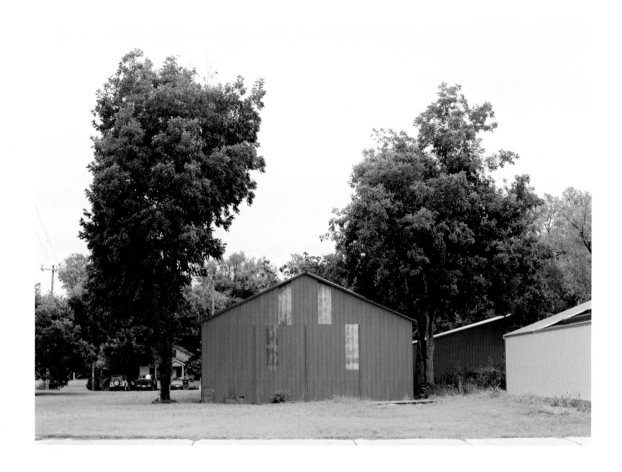

University of Iowa Press, Iowa City 52242
Copyright © 2020 by the University of Iowa Press
www.uipress.uiowa.edu
ISBN 978-1-60938-699-3 (pbk)
ISBN 978-1-60938-700-6 (ebk)
Printed in Canada by Friesens
Prepress by iocolor, Seattle

Design by Kristina Kachele Design, llc

Printed on acid-free paper

Cataloging in Publication data is on file at the Library of Congress.

Photo above: Walnut Ridge, Arkansas;
Title page: Jonesboro, Arkansas

The author would like to thank the ghosts in this machine: Karen Copp, Jim McCoy, Allison Means, and Susan Hill Newton from the University of Iowa Press; Giselle Simon, Julie Leonard, Amanda Nadelberg, Shanna and Mikey, Barb and Patrice, Nick Hotek, Jeff McNutt, Andy Adams, and everyone who happens to appear in this book.

Driving a Table Down

BARRY PHIPPS

University of Iowa Press, Iowa City

7/8/2020

On September 25, 2018, I left my house in Iowa City, Iowa, driving seven hours south to my parents' house in Rogersville, Missouri. The following day my mom and I hopped in a car, loaded down with a table for my Aunt Diane.

Mom and I drove the table twelve hundred miles to Diane's house near Sarasota, Florida, stayed a few days, then drove back.

As we traveled, we took notice how the trees slightly changed.

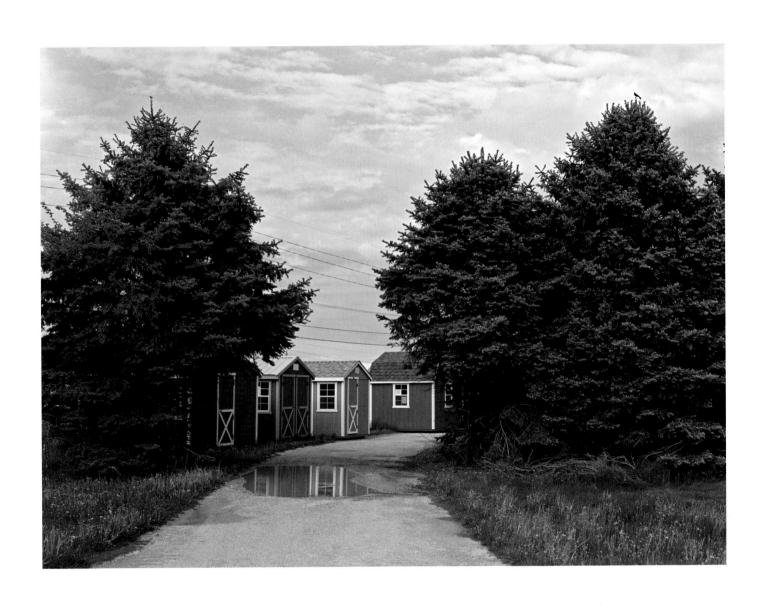

Tuesday, 9/25 · Barn-like prefab sheds for sale, rural Iowa.

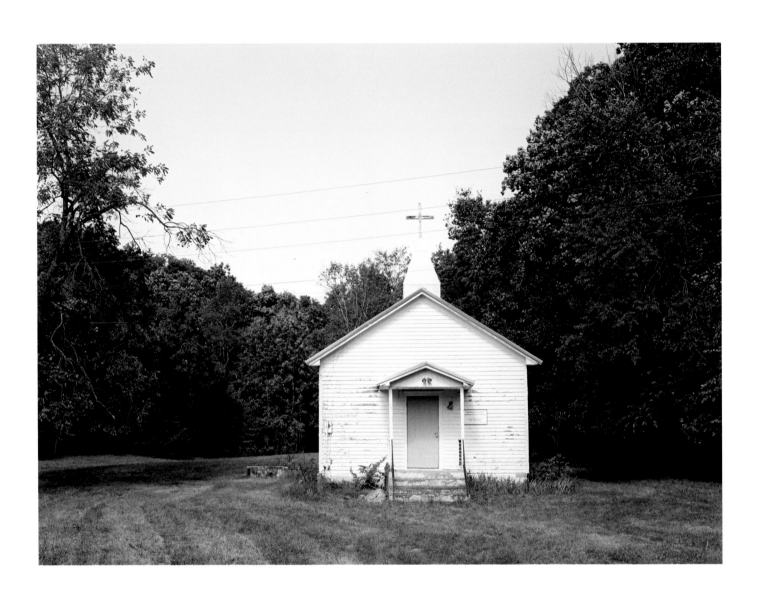

Tuesday, 9/25 · Former church in a mowed hayfield, Spalding, Missouri.

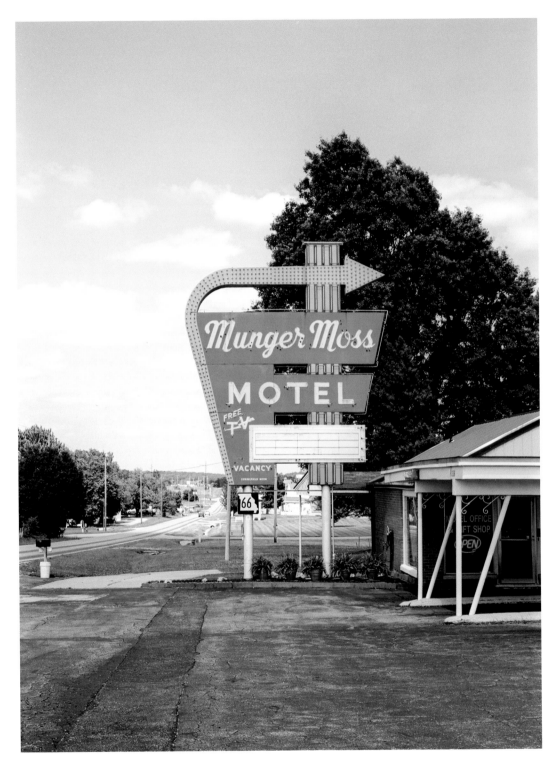

Tuesday, 9/25 · Restored signage, Route 66, Lebanon, Missouri.

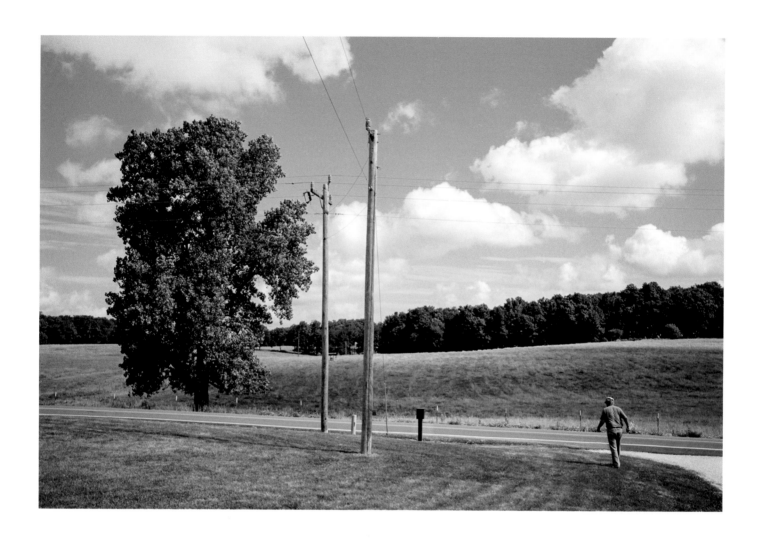

Wednesday, 9/26 · Dad getting the mail, Rogersville, Missouri.

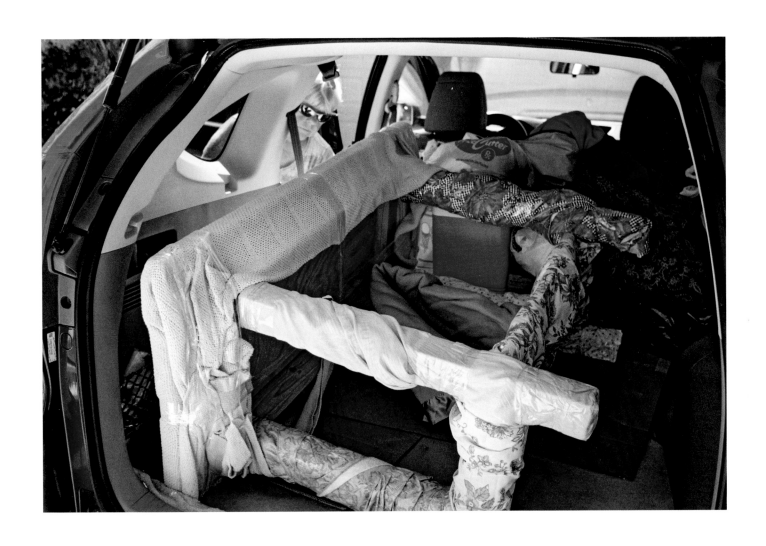

Wednesday, 9/26 · Mom loading the car, Rogersville, Missouri.

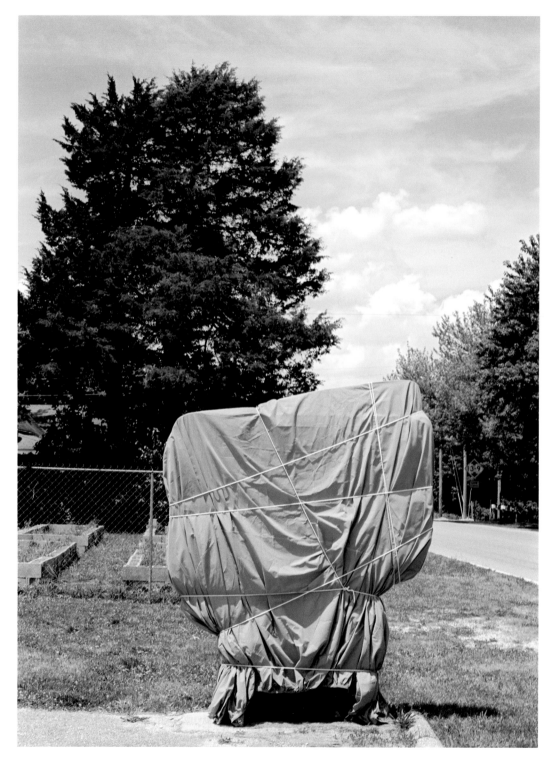

Wednesday, 9/26 · Covered signage for a former church, Fordland, Missouri.

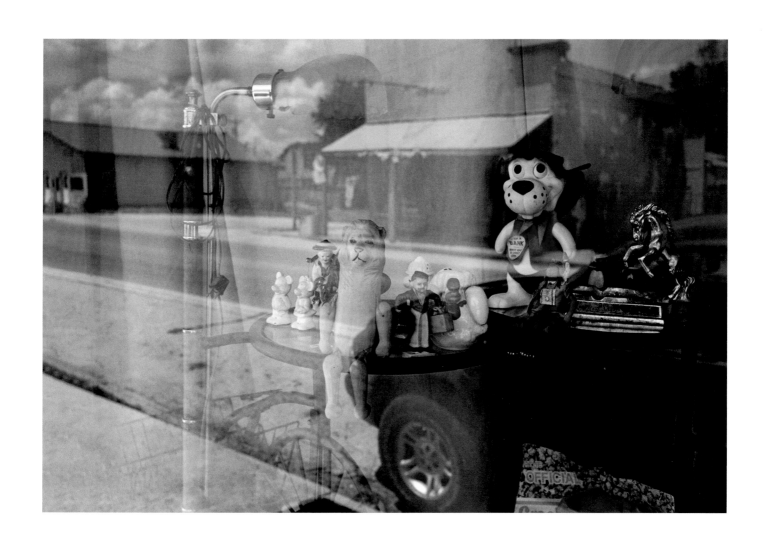

Wednesday, 9/26 · Fordland, Missouri.

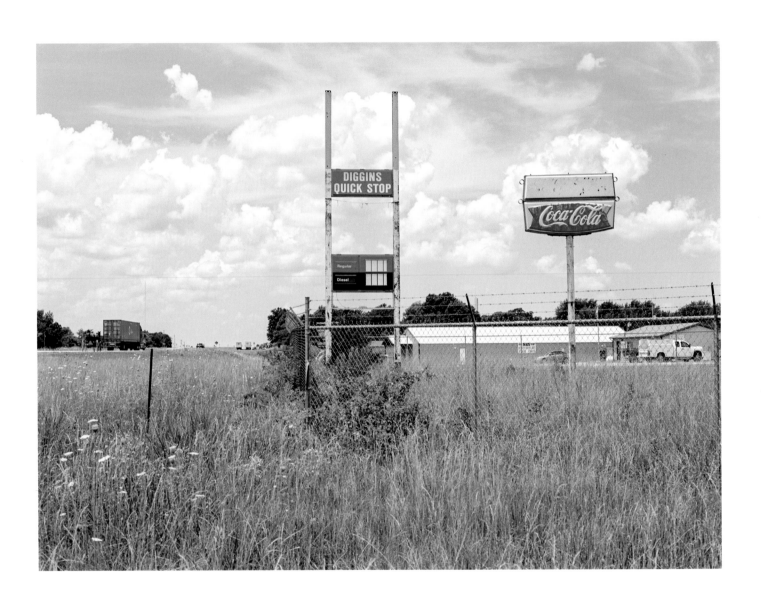

Wednesday, 9/26 · Diggins, Missouri.

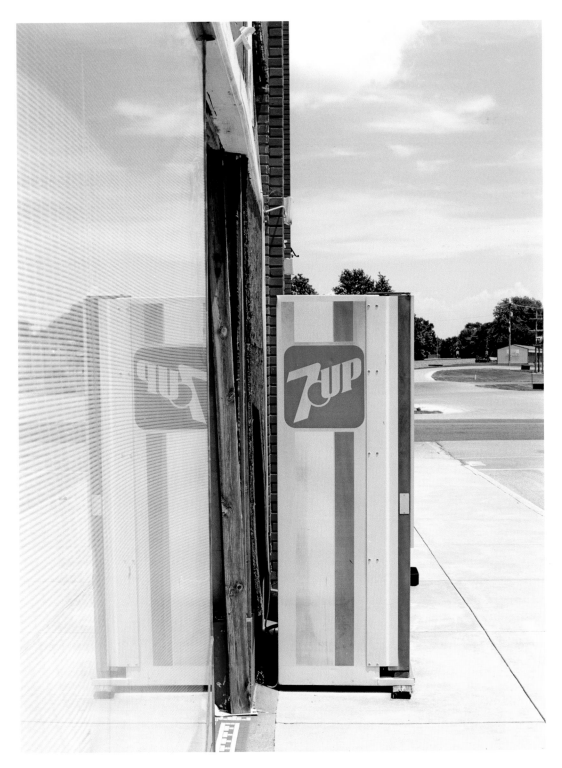

Wednesday, 9/26 · Seymour, Missouri.

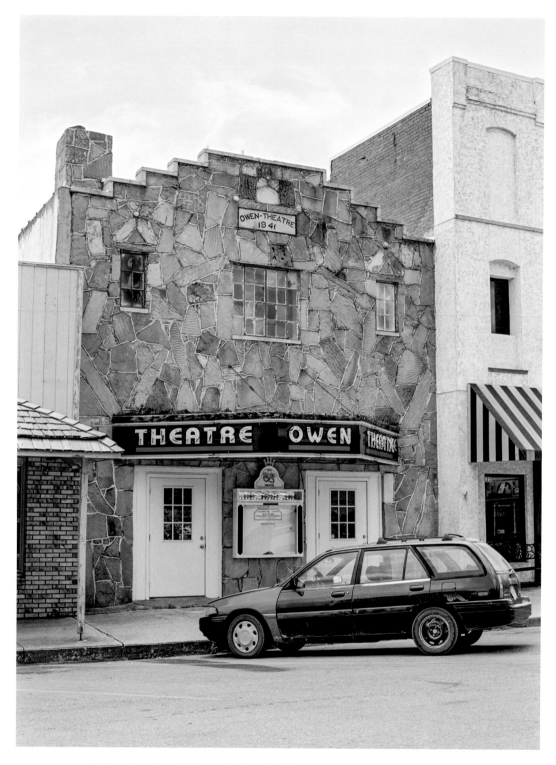

Wednesday, 9/26 · Fieldstone building (and former all-blue car), Seymour, Missouri.

Wednesday, 9/26 · (Mostly) blue building, Seymour, Missouri.

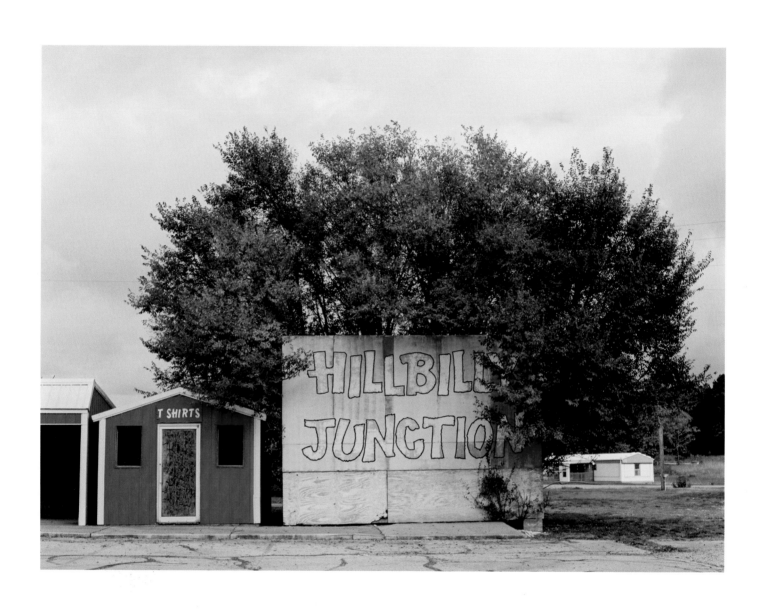

Wednesday, 9/26 · Former tourist trap, Willow Springs, Missouri.

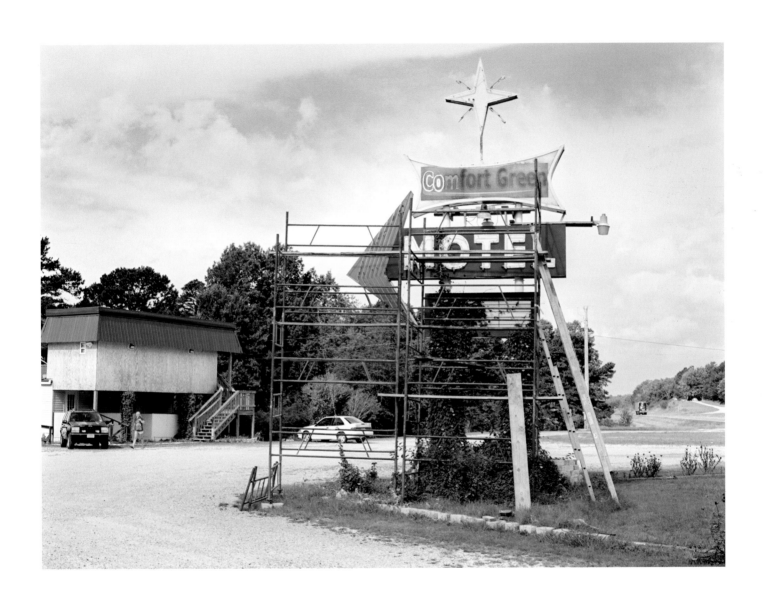

Wednesday, 9/26 · Signage restoration (in progress), Thayer, Missouri.

Wednesday, 9/26 · Porter Wagoner Boulevard, West Plains, Missouri.

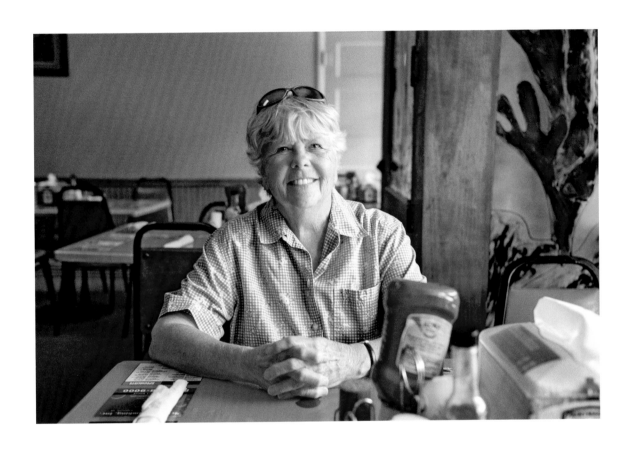

Wednesday, 9/26 · Mom at Fred's Fish House (her favorite restaurant), Mammoth Spring, Arkansas.

Wednesday, 9/26 • Red dirt parking lot, Hardy, Arkansas.

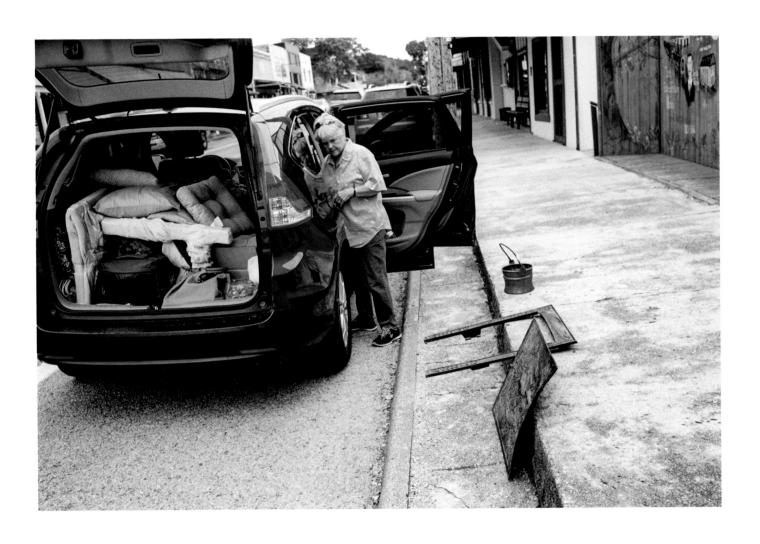

Wednesday, 9/26 · Mom with recently purchased antiques, Hardy, Arkansas.

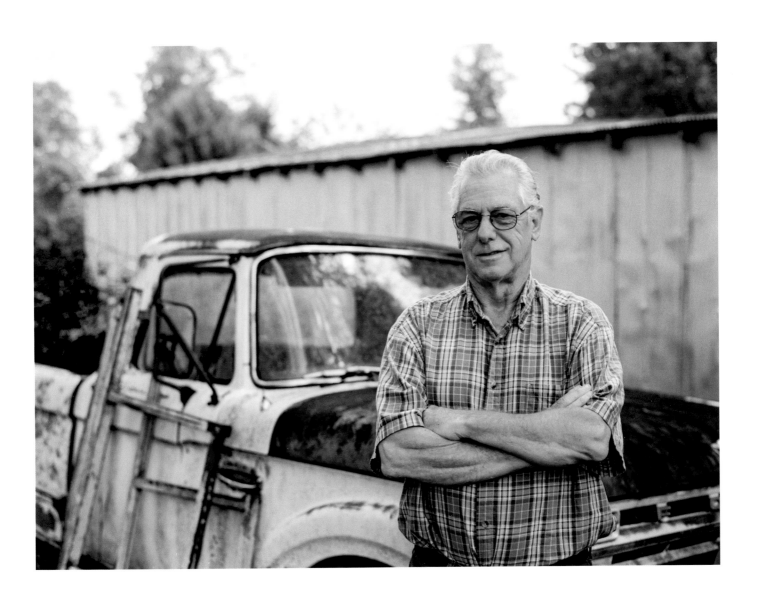

Wednesday, 9/26 · Uncle Dale, Hardy, Arkansas.

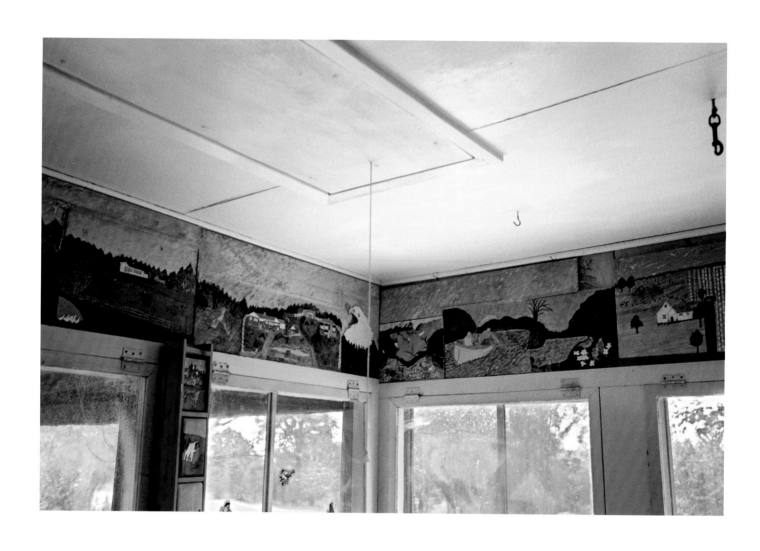

Thursday, 9/27 · Grandfather C. A. Carmack paintings, Hardy, Arkansas.

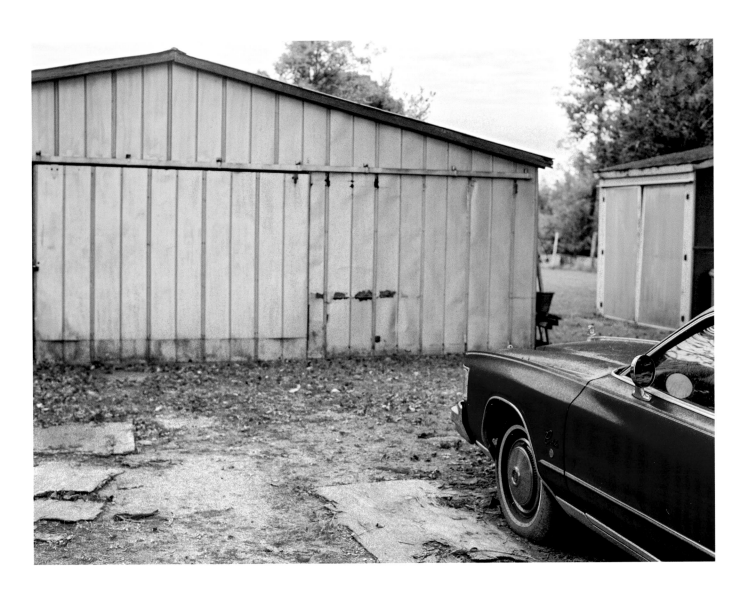

Thursday, 9/27 · The shed (and Grandma and Grandpa's old Cordoba), Hardy, Arkansas.

Thursday, 9/27 · Ravenden, Arkansas.

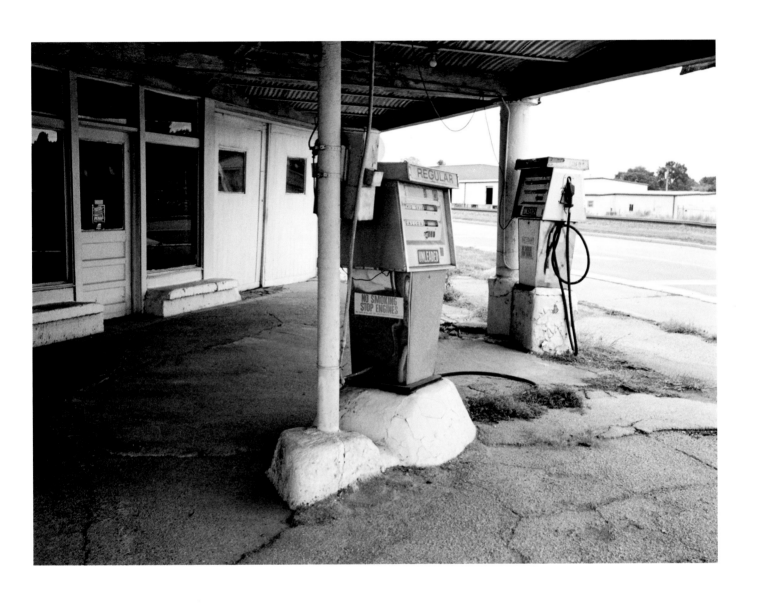

Thursday, 9/27 · Elevated gas pumps in the lowlands, Hoxie, Arkansas.

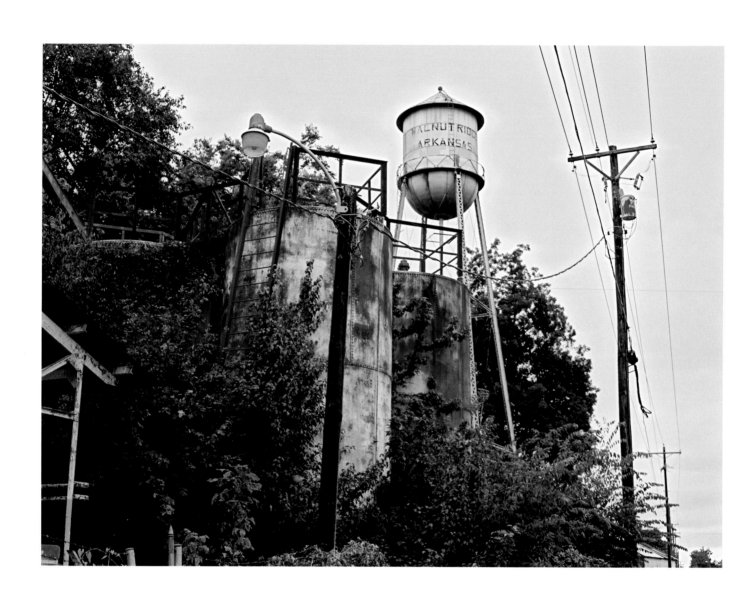

Thursday, 9/27 · Walnut Ridge, Arkansas.

Thursday, 9/27 · Hoxie, Arkansas.

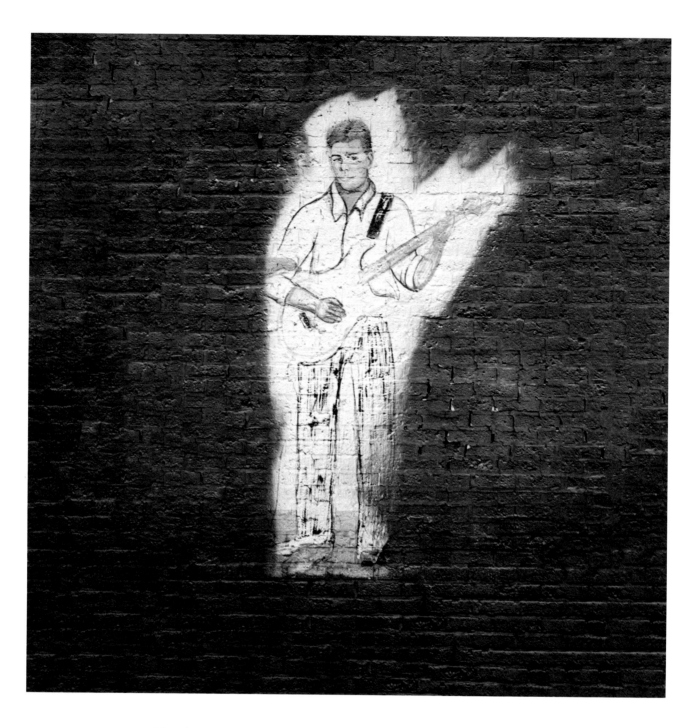

Thursday, 9/27 · Guitarist, spared from a coat of blue paint, Walnut Ridge, Arkansas.

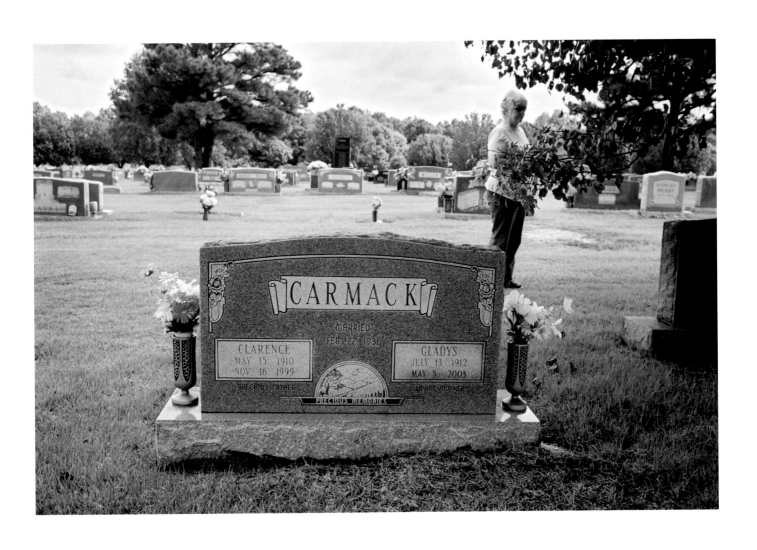

Thursday, 9/27 · Mom at her parents' gravesite, Jonesboro, Arkansas.

Thursday, 9/27 · Mural restoration (in progress), Black Oak, Arkansas.

Thursday, 9/27 · Caraway, Arkansas.

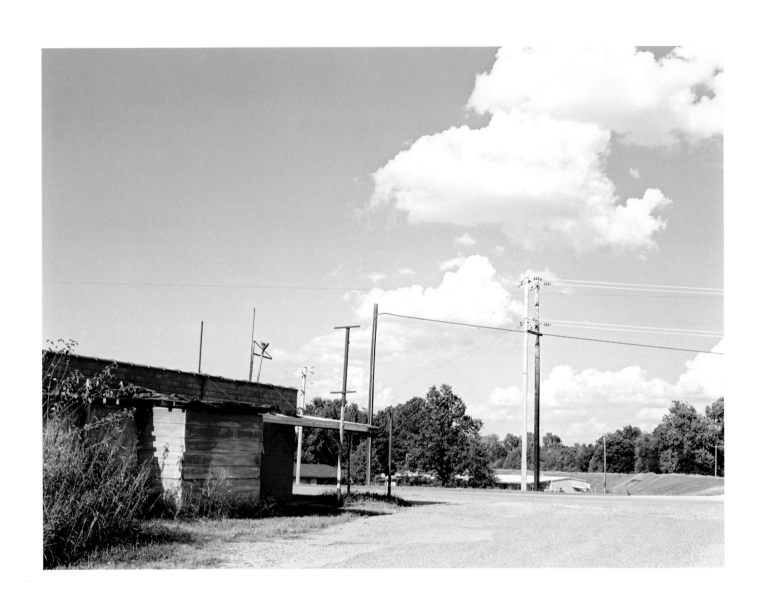

Thursday, 9/27 · Rivervale, Arkansas.

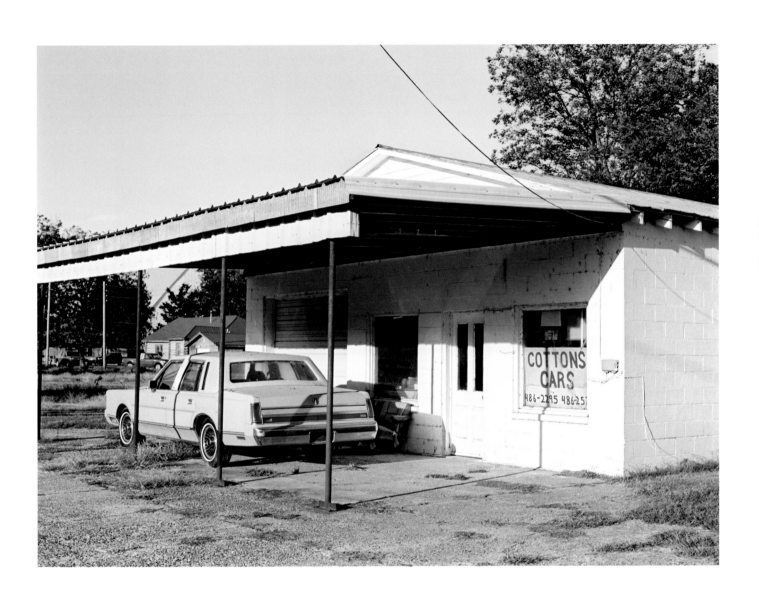

Thursday, 9/27 · Black Oak, Arkansas.

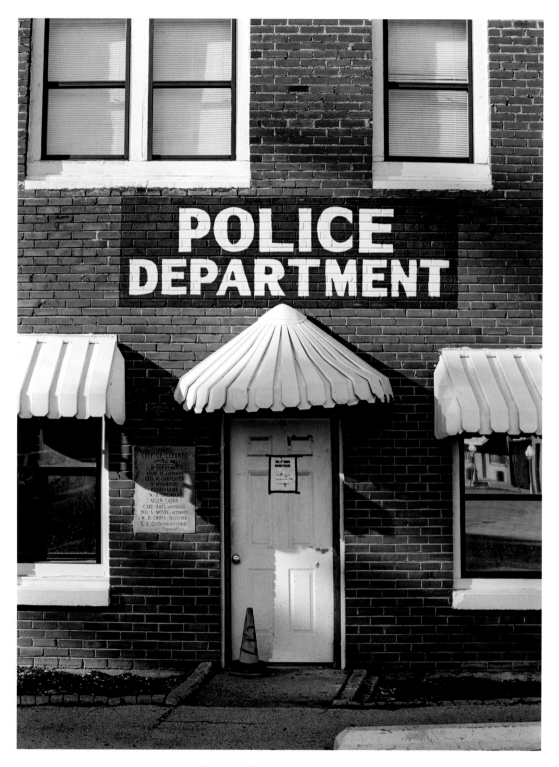

Thursday, 9/27 · Lepanto, Arkansas.

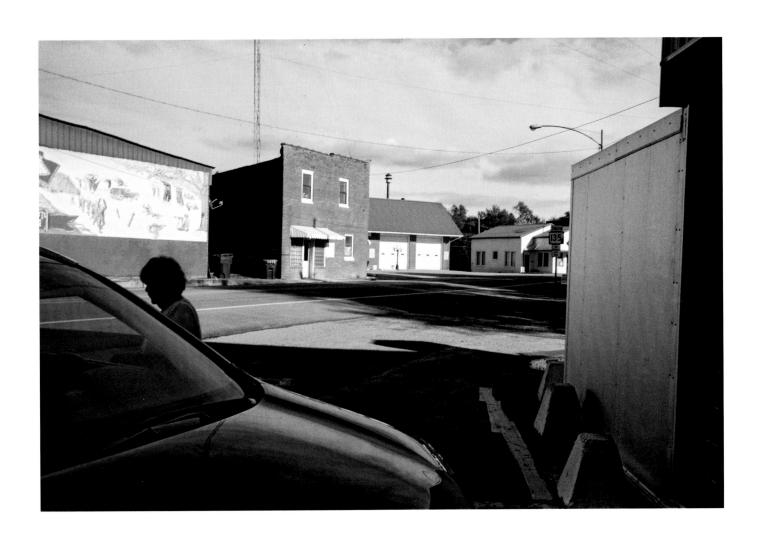

Thursday, 9/27 · Lepanto, Arkansas.

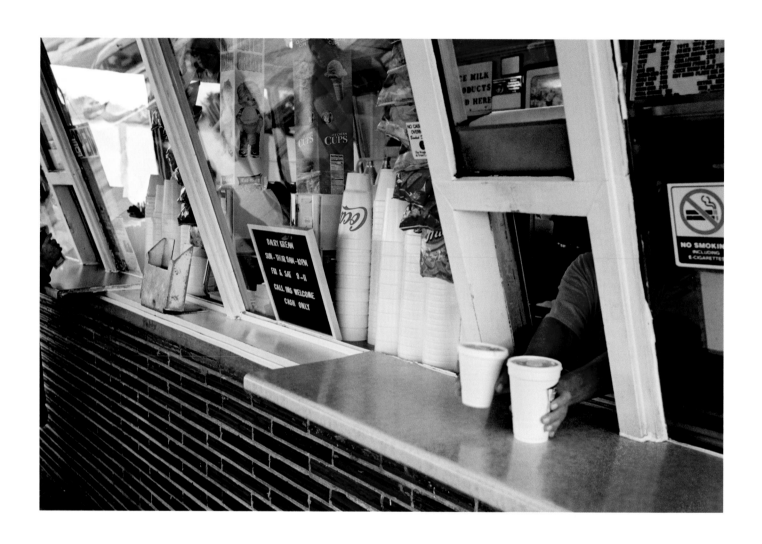

Friday, 9/28 · Tupelo, Mississippi.

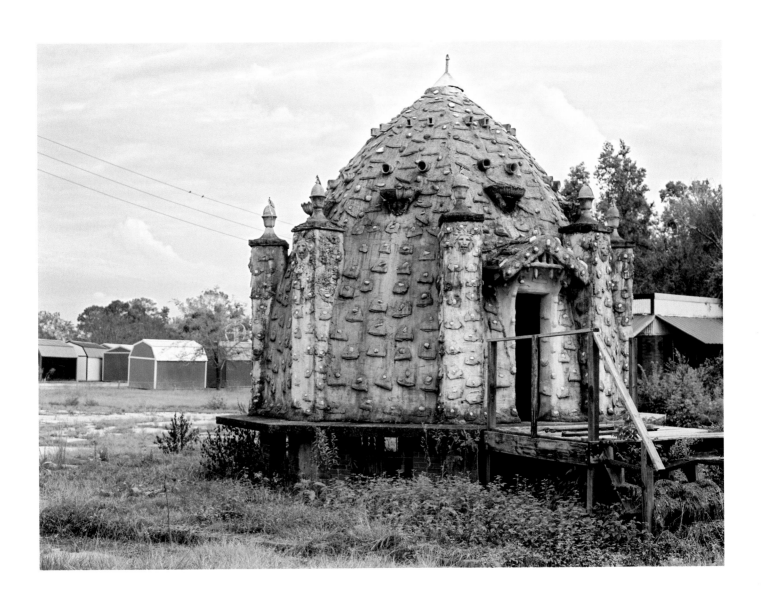

Friday, 9/28 · Former tourist attraction (and prefab storage sheds for sale), Prattsville, Alabama.

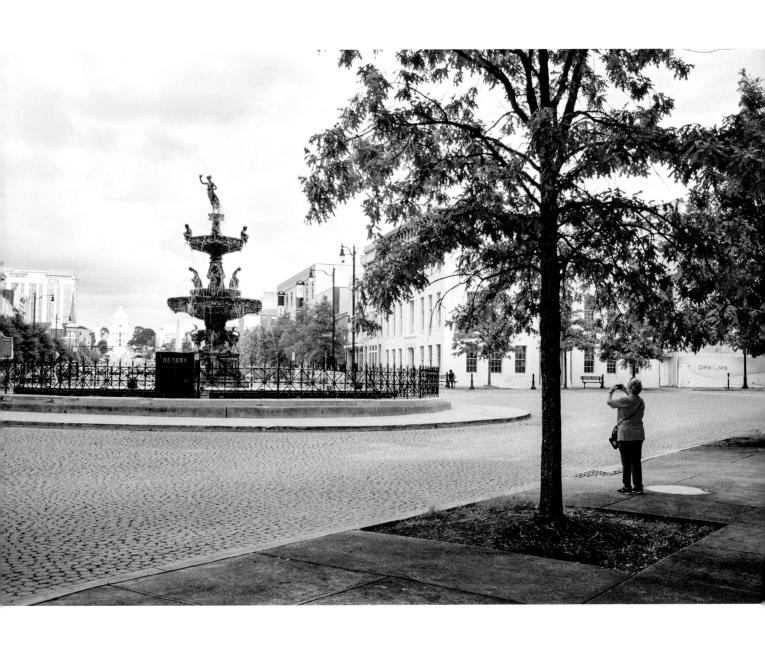

Friday, 9/28 · Montgomery, Alabama.

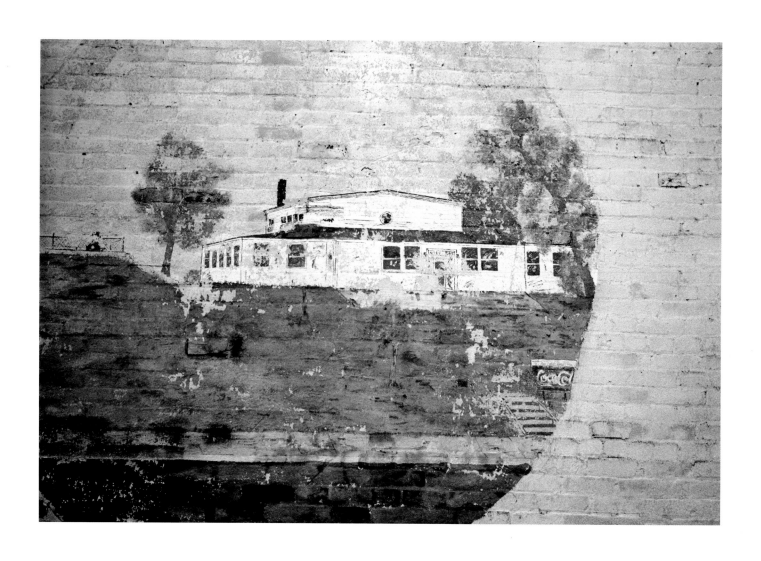

Saturday, 9/29 · Ozark, Alabama.

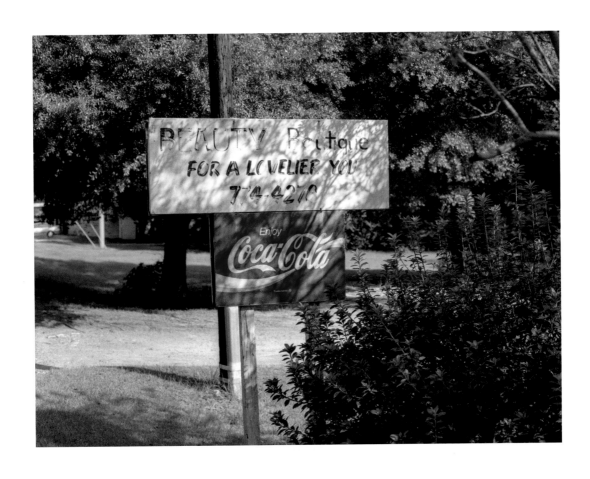

Saturday, 9/29 • Ozark, Alabama.

Saturday, 9/29 · Lamont, Florida.

Saturday, 9/29 · Aunt Diane and Uncle Dick's house, Sarasota, Florida.

Sunday, 9/30 · Sarasota, Florida.

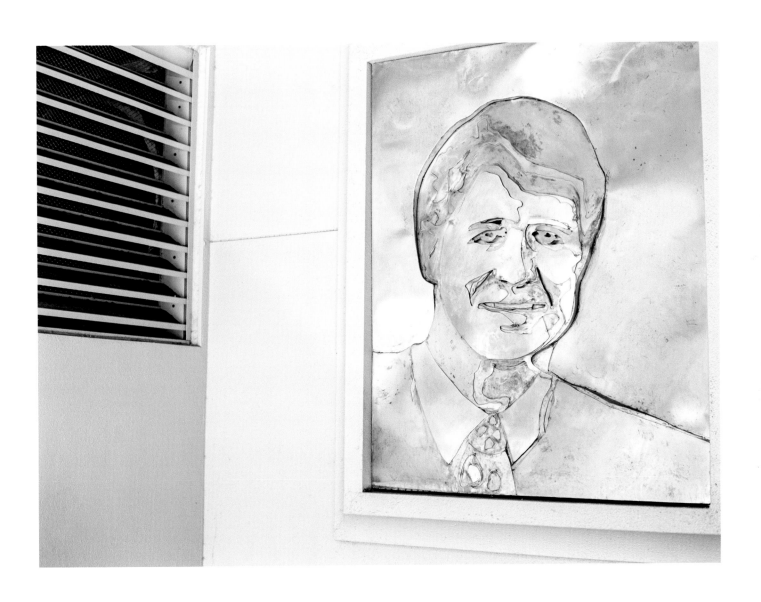

Sunday, 9/30 · Sarasota, Florida.

Sunday, 9/30 · Cousin Tim, Sarasota, Florida.

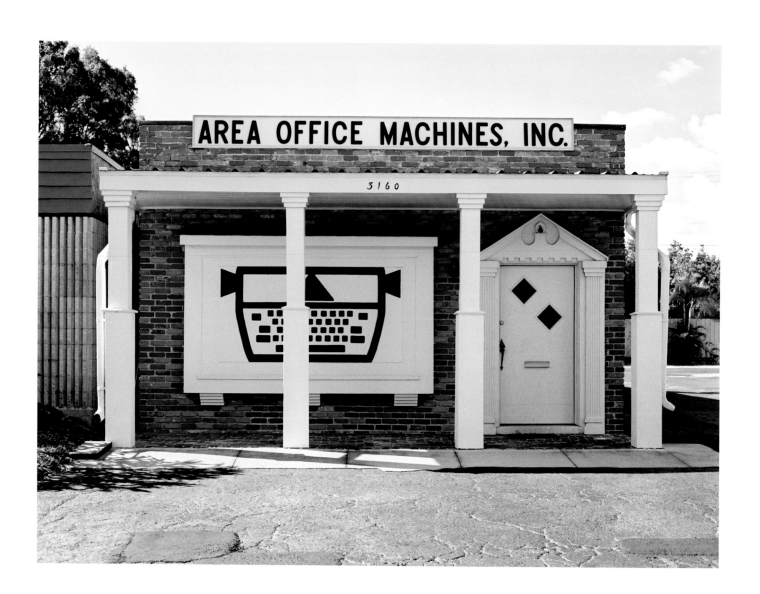

Sunday, 9/30 • Sarasota, Florida.

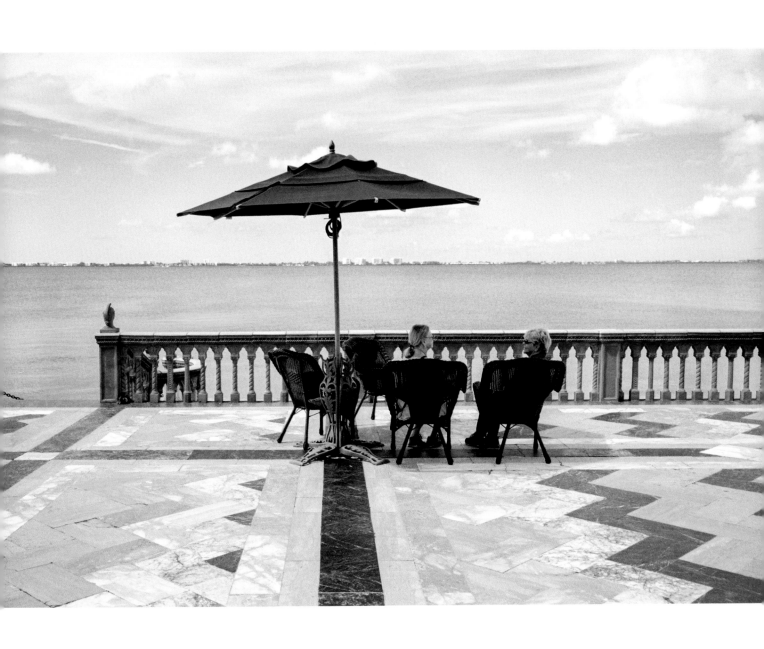

Monday, 10/1 · Mom and Aunt Diane, Sarasota, Florida.

Monday, 10/1 · Sarasota, Florida.

Monday, 10/1 · Aunt Diane (and signage graveyard), Sarasota, Florida.

Monday, 10/1 · Sarasota, Florida.

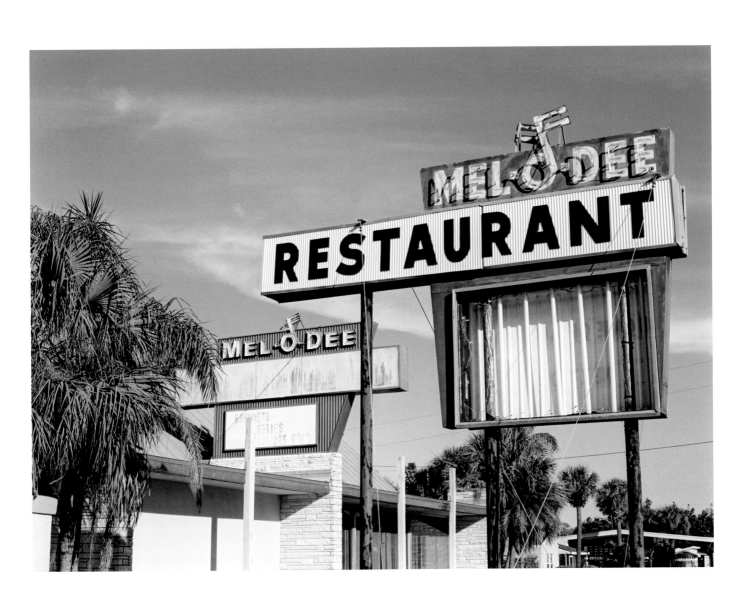

Monday, 10/1 · Sarasota, Florida.

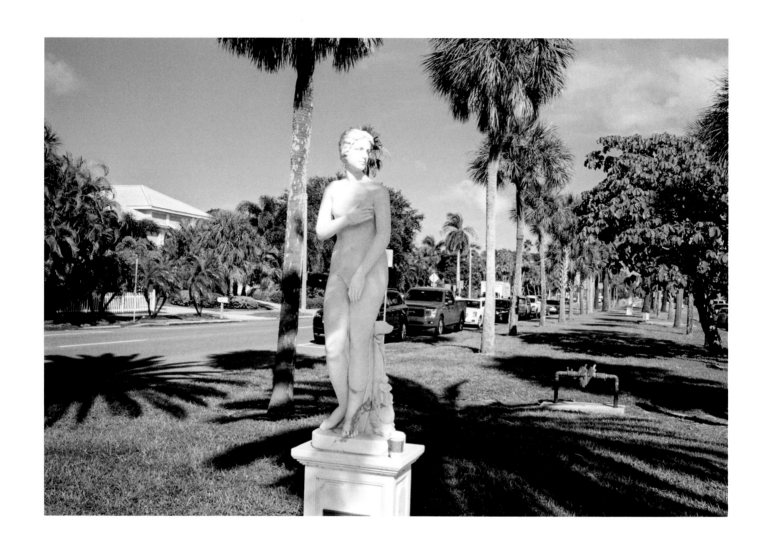

Monday, 10/1 • Statue (next to car pictured on the right), North Boulevard of the Presidents, St. Armand's Key, Sarasota, Florida.

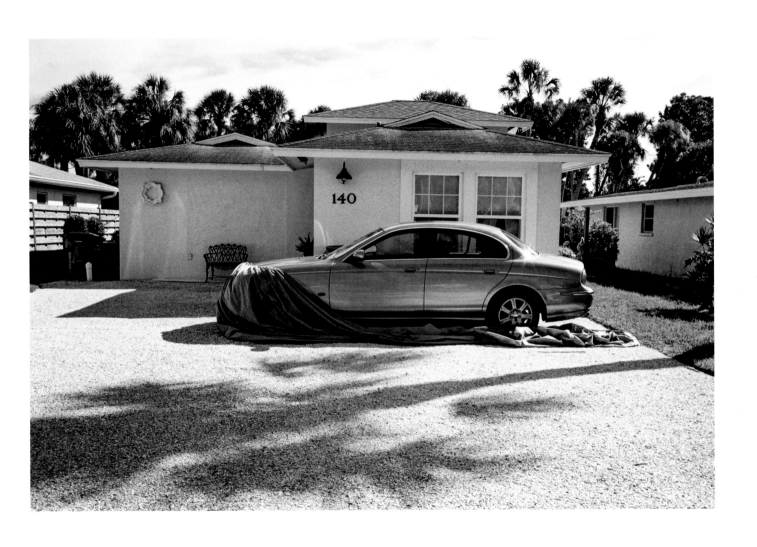

Monday, 10/1 · Car (next to statue pictured on the left), North Boulevard of the Presidents, St. Armand's Key, Sarasota, Florida.

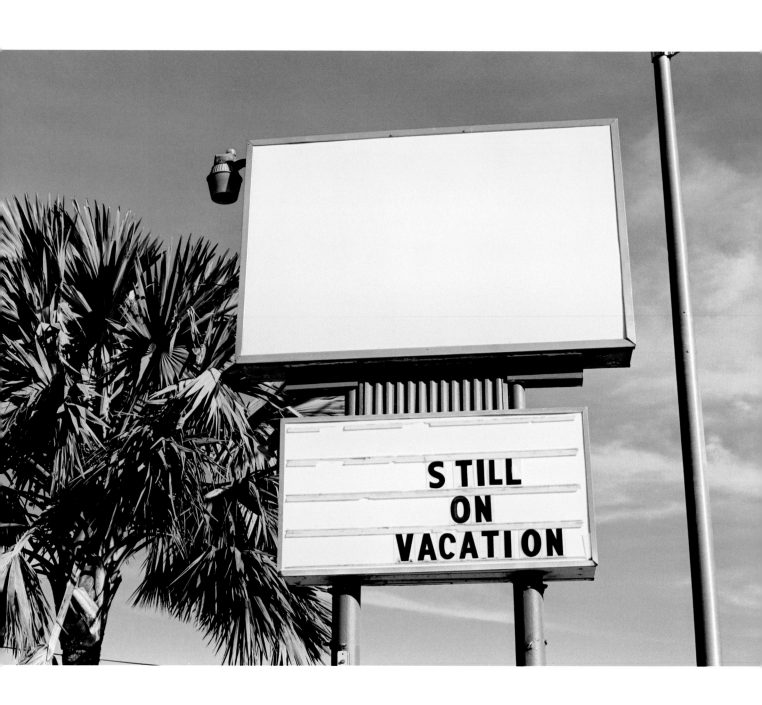

Monday, 10/1 · Sarasota, Florida.

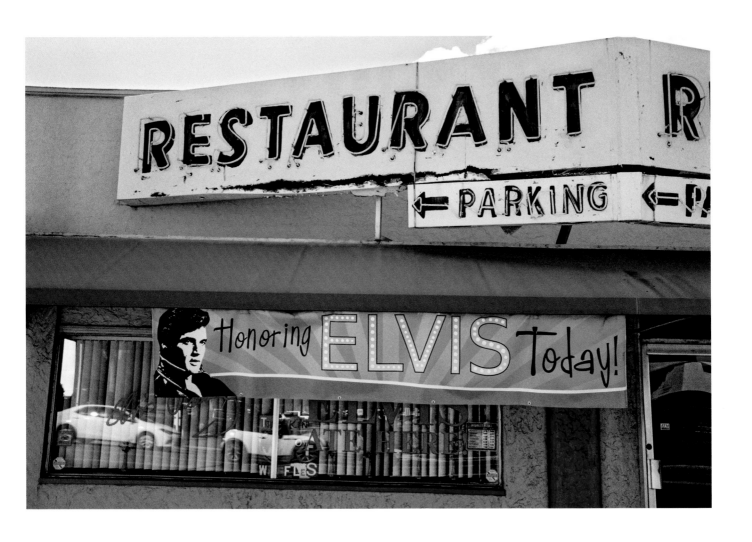

Monday, 10/1 · Restaurant where Elvis once dined, Sarasota, Florida.

Monday, 10/1 · Sarasota, Florida.

Monday, 10/1 · Sarasota, Florida.

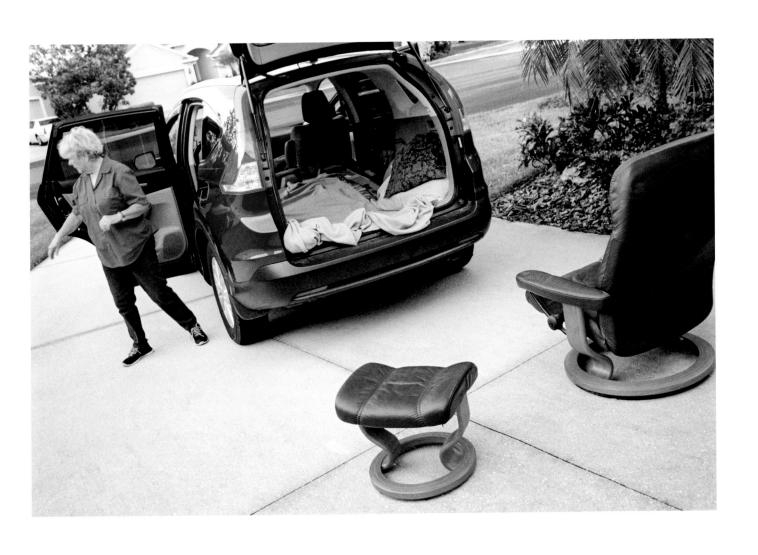

Tuesday, 10/2 · Mom loading Uncle Dick's chair, Bradenton, Florida.

Tuesday, 10/2 · Alachua, Florida.

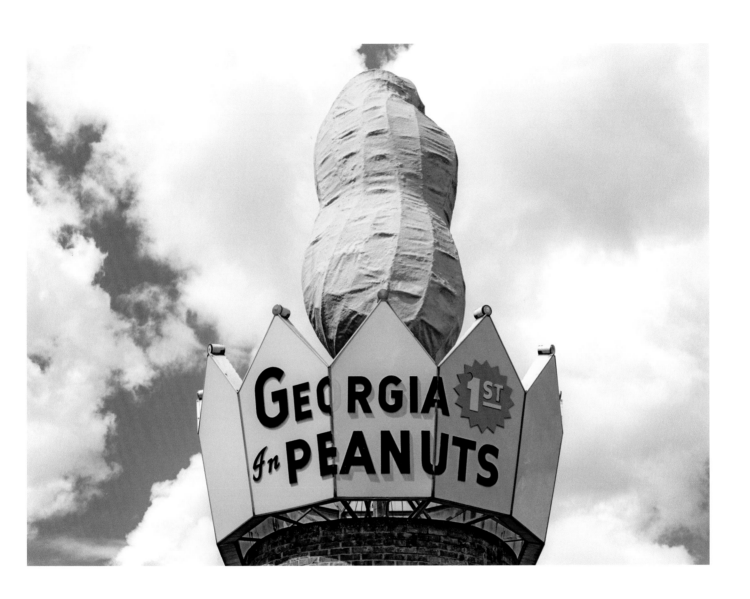

Tuesday, 10/2 • Tifton, Georgia.

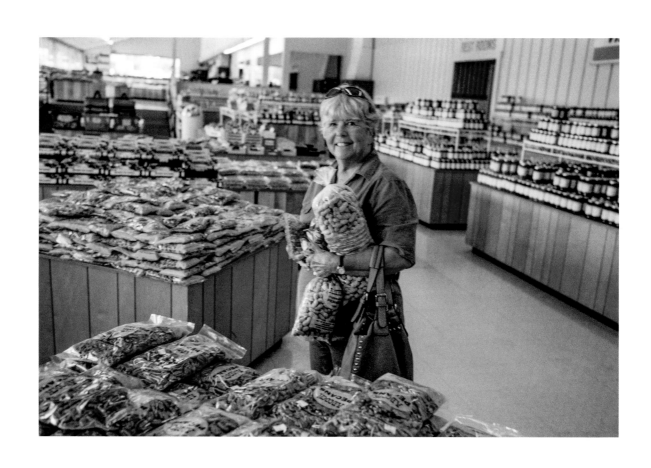

Tuesday, 10/2 · Mom buying gifts, Tifton, Georgia.

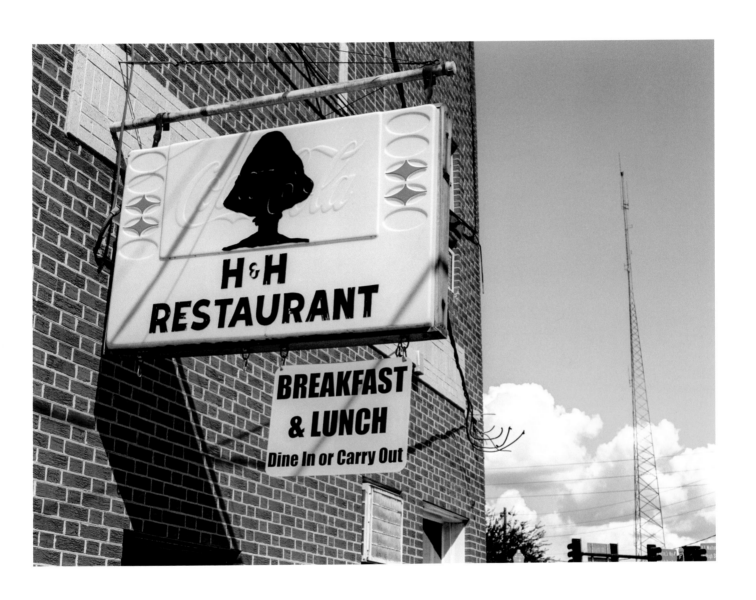

Tuesday, 10/2 · Painted-over Coca-Cola sign, Macon, Georgia.

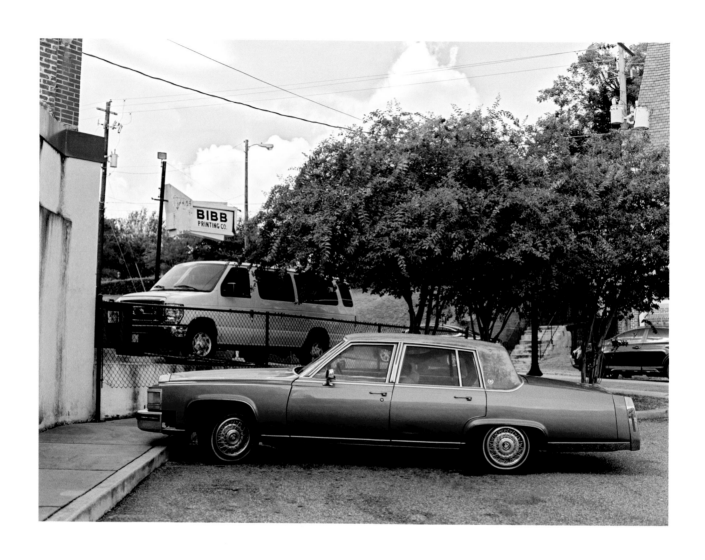

Tuesday, 10/2 • Macon, Georgia.

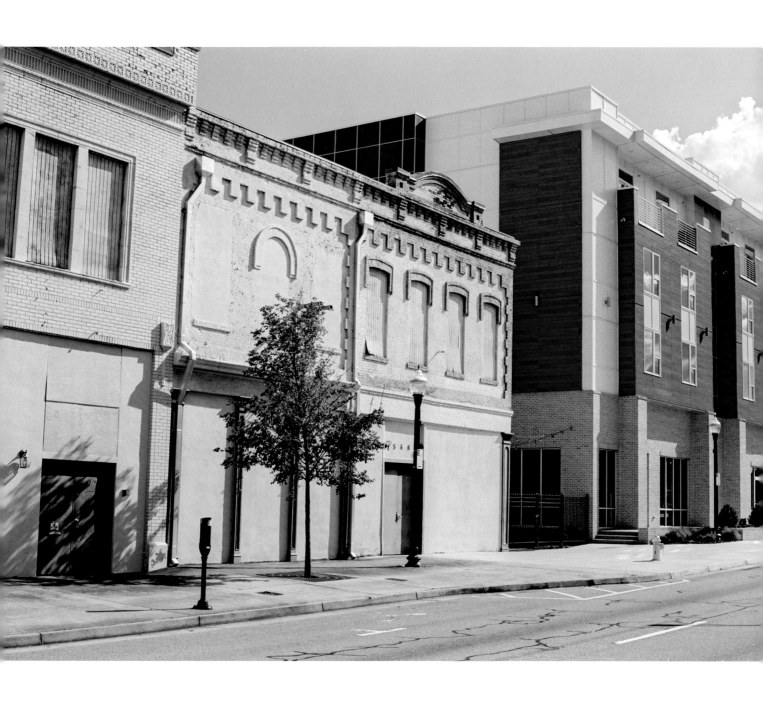

Tuesday, 10/2 · Former recording studio beside new lofts, Macon, Georgia.

Tuesday, 10/2 · Villa Rica, Georgia.

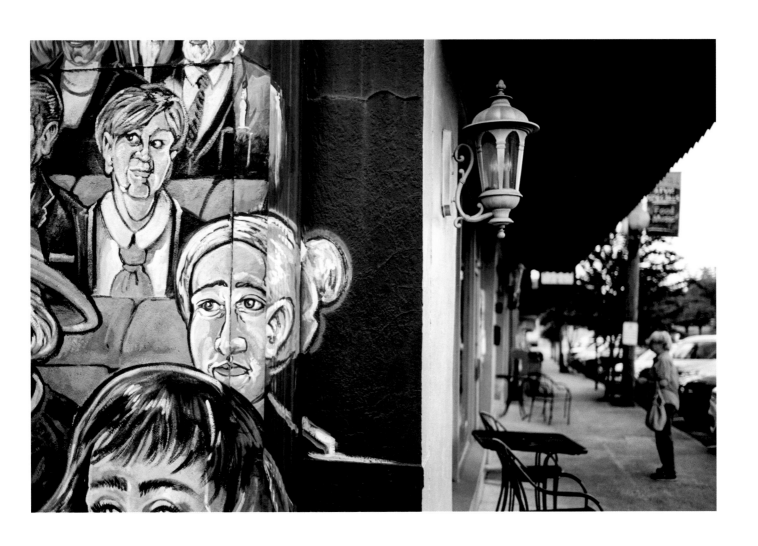

Tuesday, 10/2 · Villa Rica, Georgia.

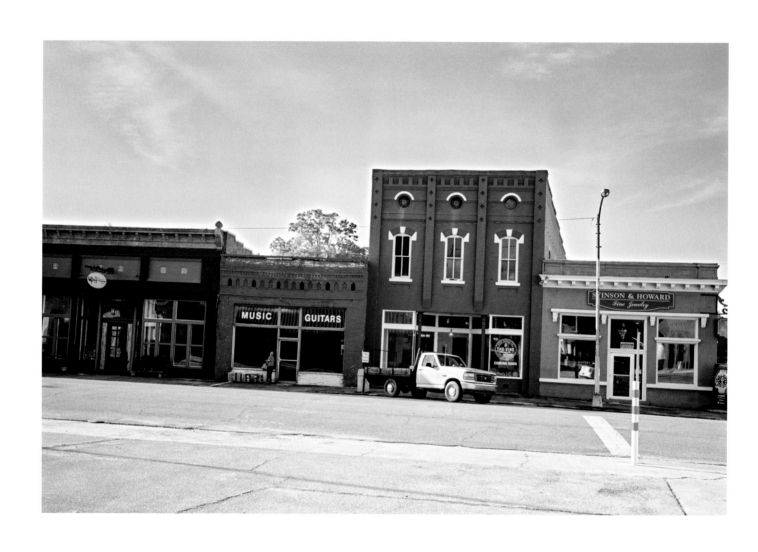

Wednesday, 10/3 · Oxford, Alabama.

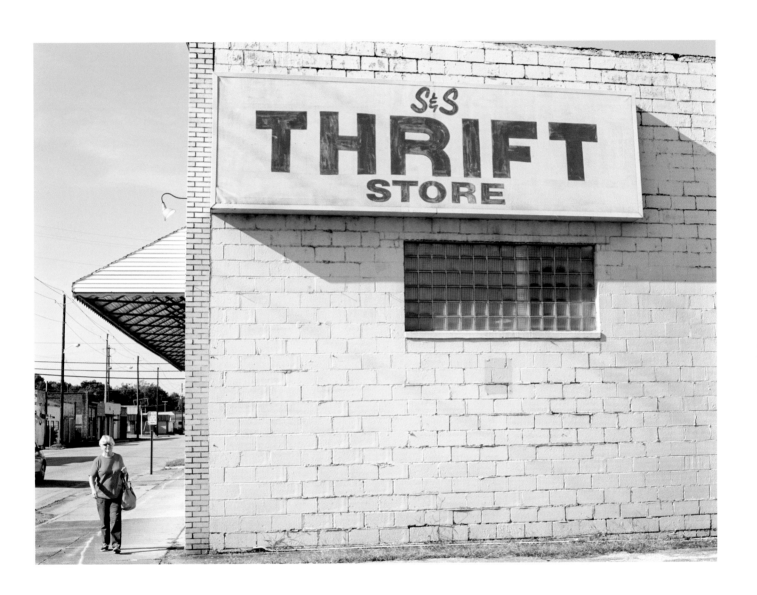

Wednesday, 10/3 · Birmingham, Alabama.

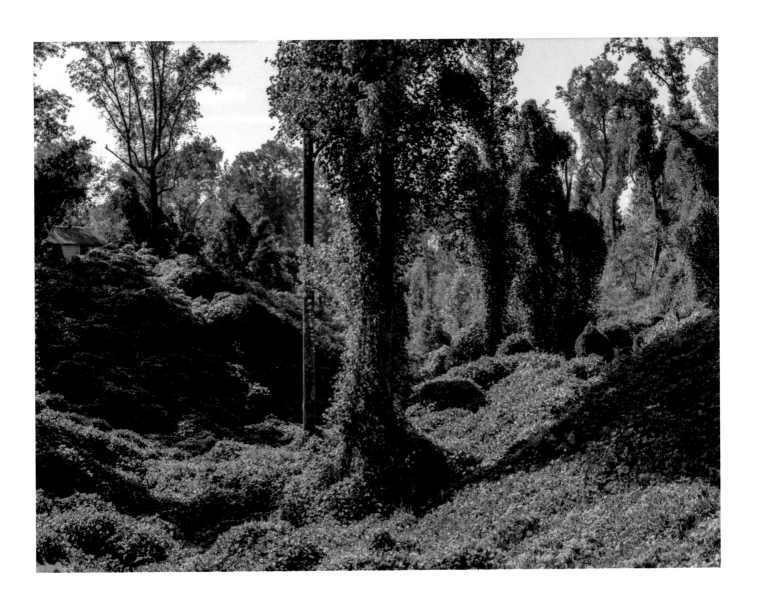

Wednesday, 10/3 · Graysville, Alabama.

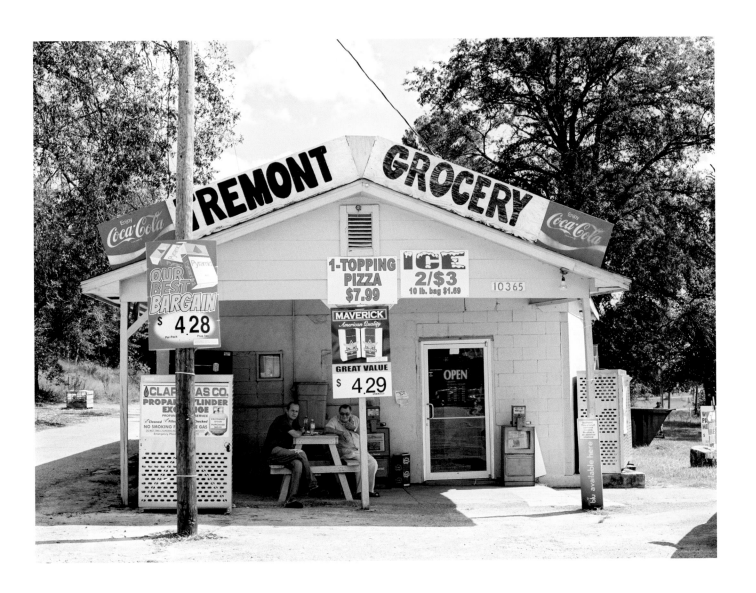

Wednesday, 10/3 · Store owner and friend (in Tammy Wynette's hometown), Tremont, Mississippi.

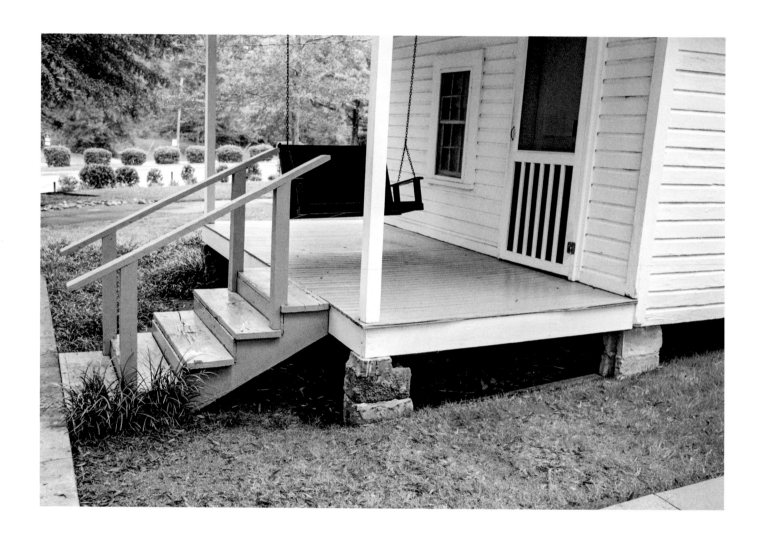

Wednesday, 10/3 · Restored childhood home of Elvis Presley, Tupelo, Mississippi.

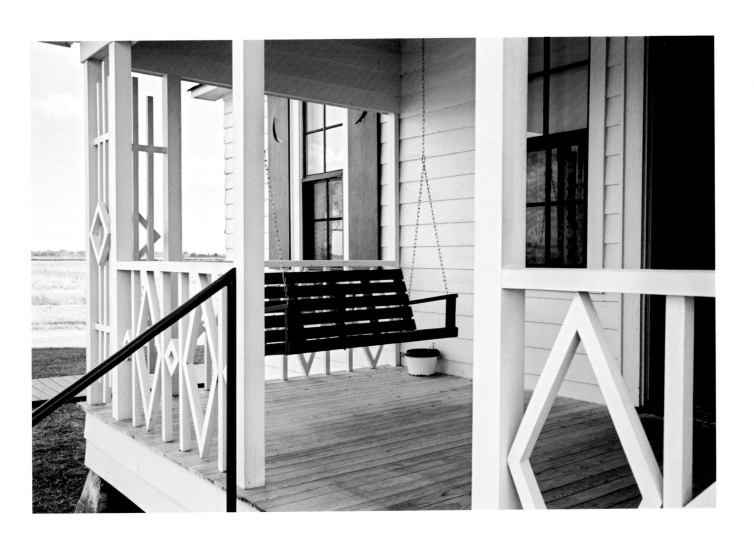

Wednesday, 10/3 · Restored childhood home of Johnny Cash, Dyess, Arkansas.

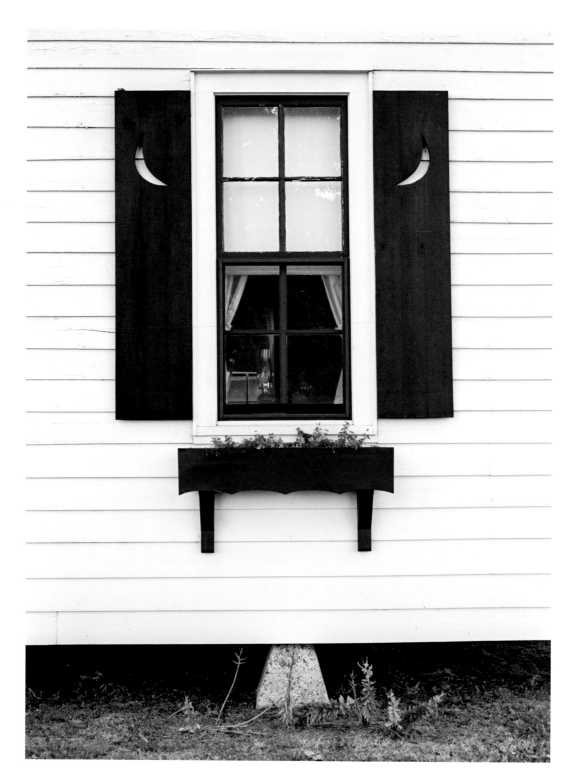

Wednesday, 10/3 · Dyess, Arkansas.

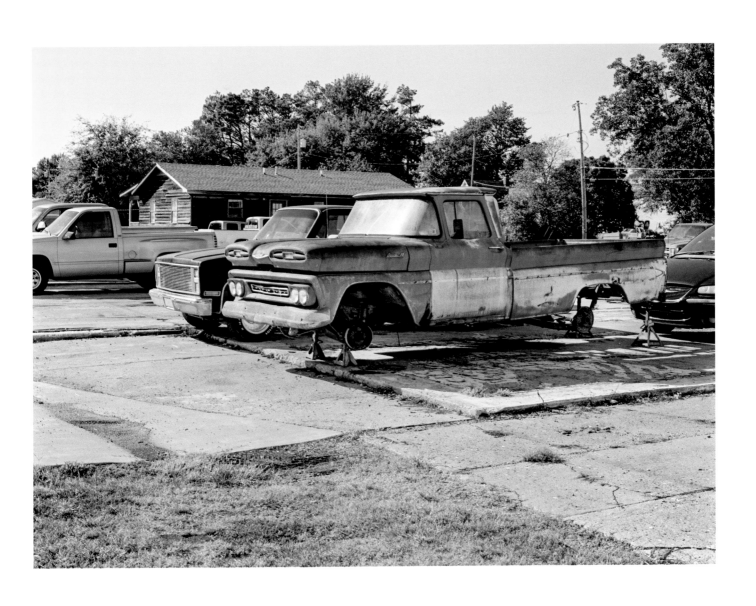

Wednesday, 10/3 · Caraway, Arkansas.

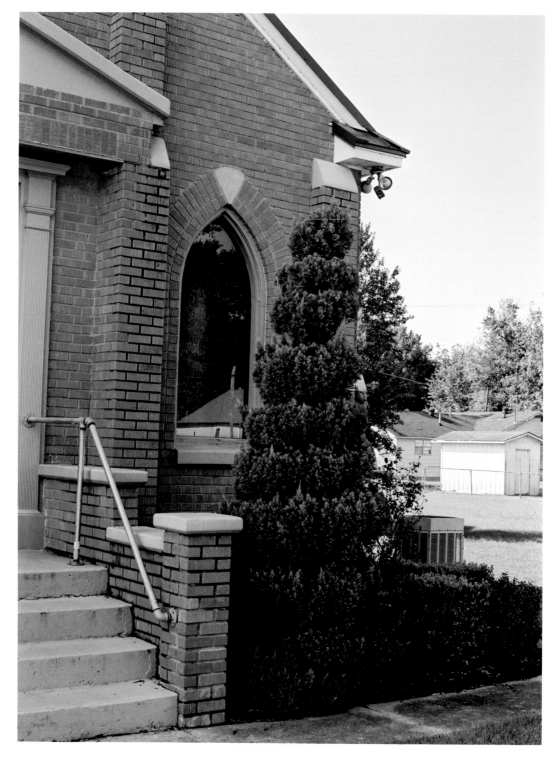

Wednesday, 10/3 · Church built by Grandfather C. A. Carmack, Caraway, Arkansas.

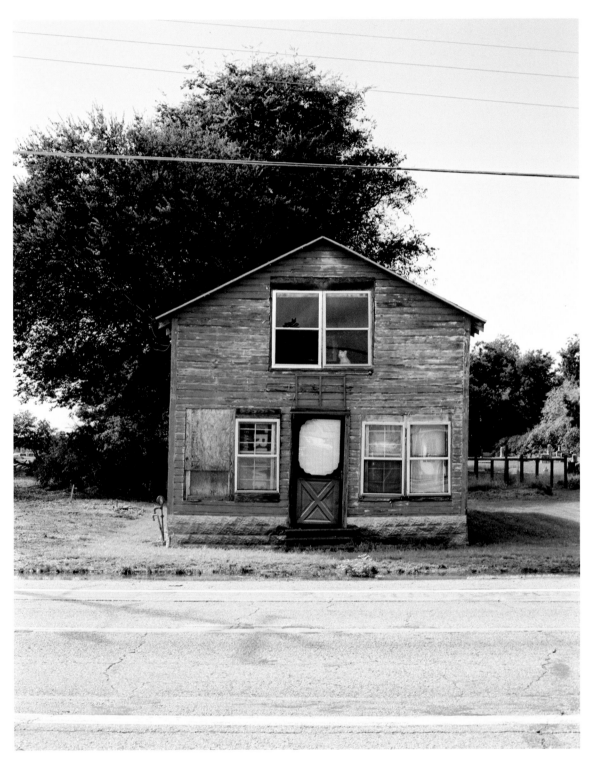

Wednesday, 10/3 · Black Oak, Arkansas.

Wednesday, 10/3 · Black Oak, Arkansas.

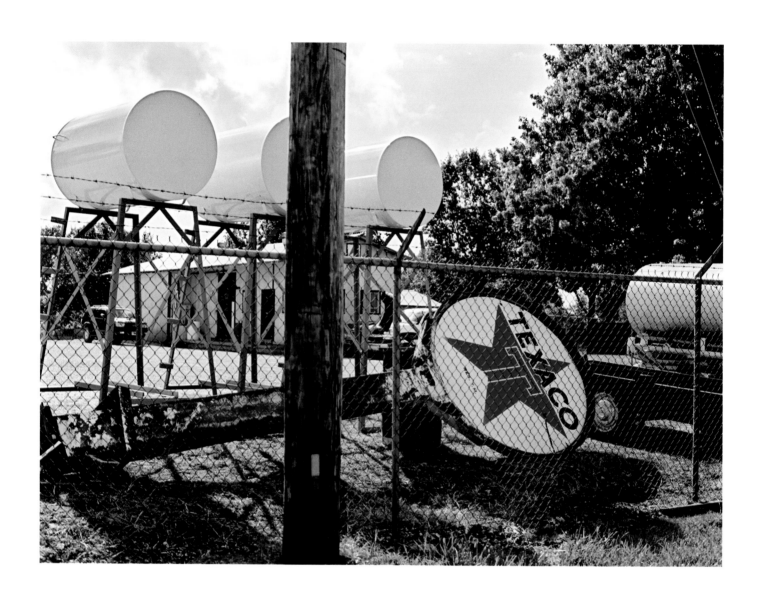

Thursday, 10/4 · Former signage for Dale and Doyle's Texaco station, Hardy, Arkansas.

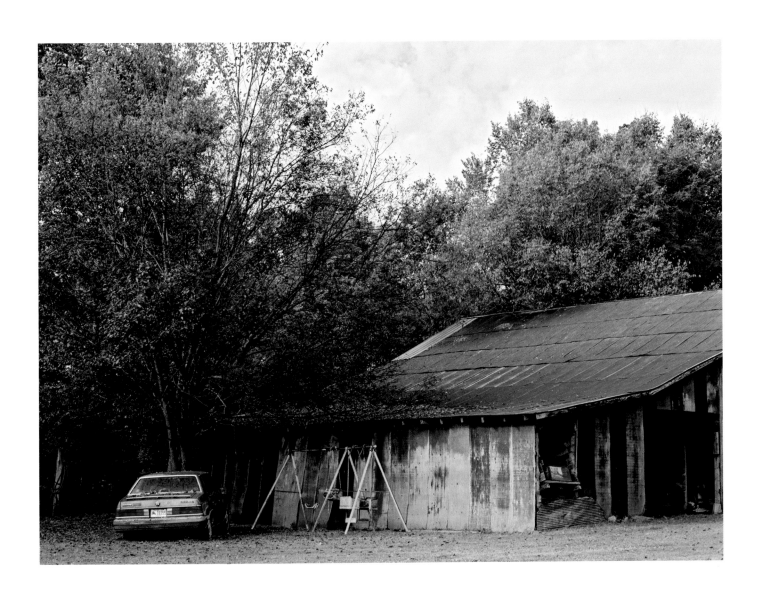

Thursday, 10/4 · Hardy, Arkansas.

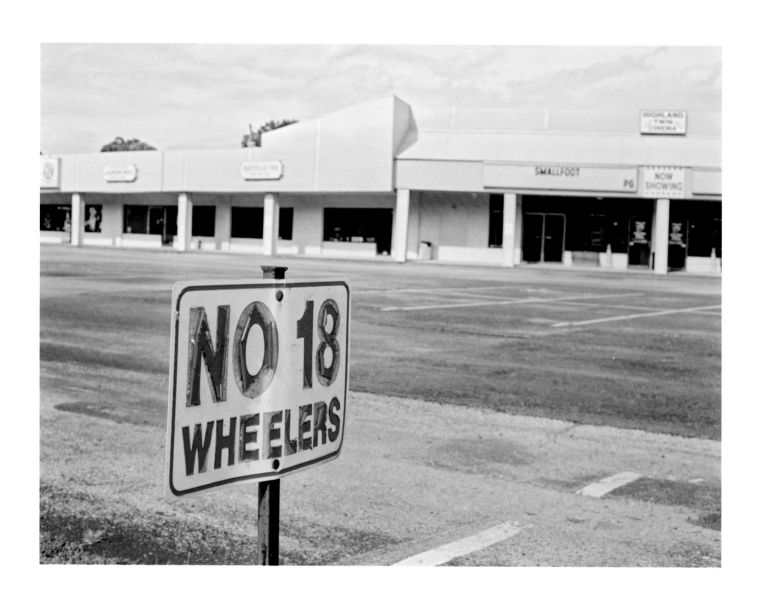

Thursday, 10/4 · Hardy, Arkansas.

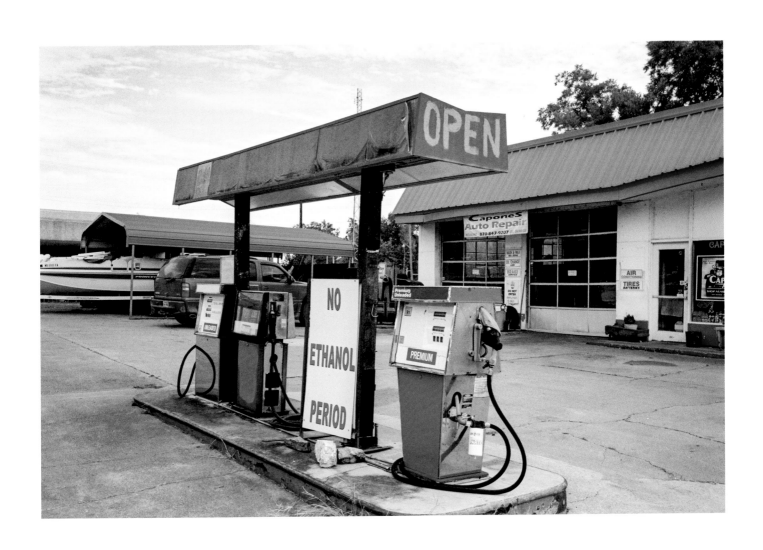

Thursday, 10/4 · Hardy, Arkansas.

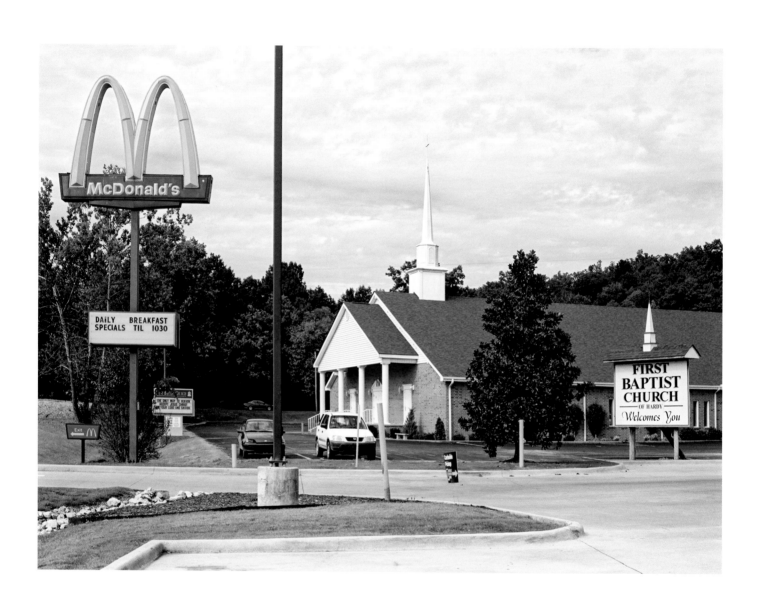

Thursday, 10/4 · Baptist church, Hardy, Arkansas.

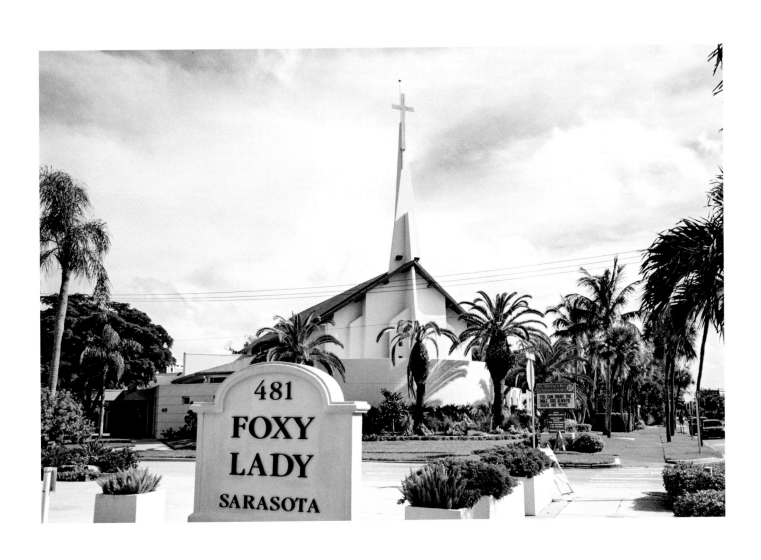

Monday, 10/1 · Taken a few days prior, Lutheran church, St. Armand's Key, Sarasota, Florida.

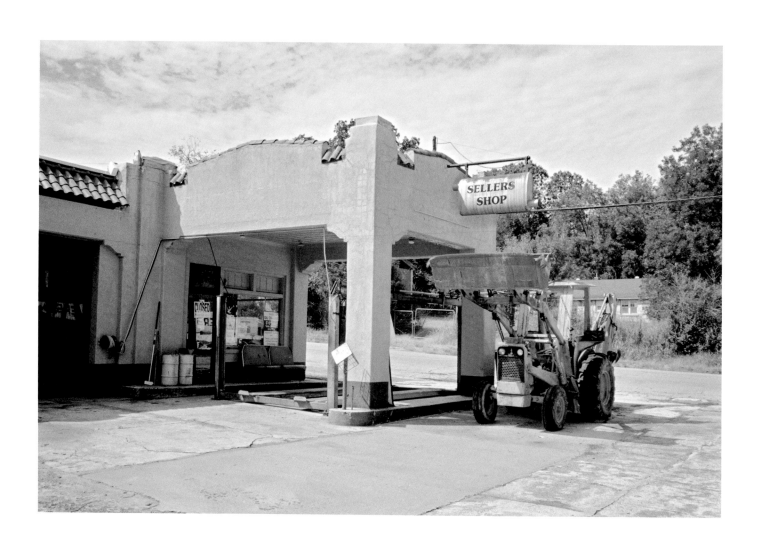

Thursday, 10/4 · Former gas station, Thayer, Missouri.

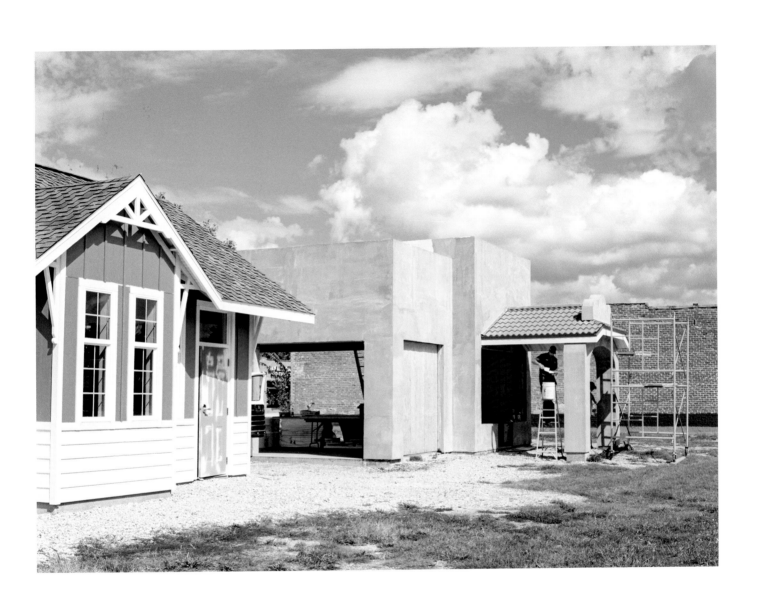

Thursday, 10/4 · New construction of an old-style gas station, Route 66, Strafford, Missouri.

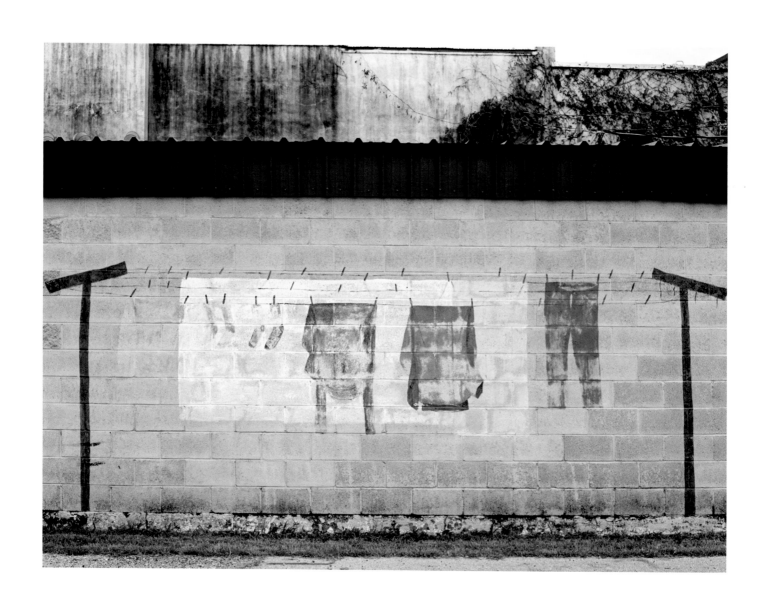

Thursday, 10/4 · Laundromat mural (across the street from placards pictured on the right), East 1st Street, Willow Springs, Missouri.

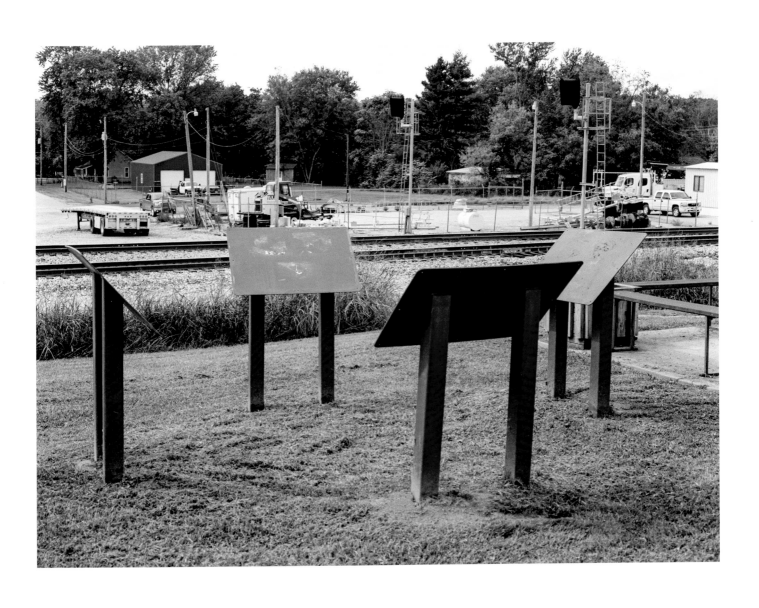

Thursday, 10/4 · Former informative placards for tourism (across the street from mural pictured on the left), East 1st Street, Willow Springs, Missouri.

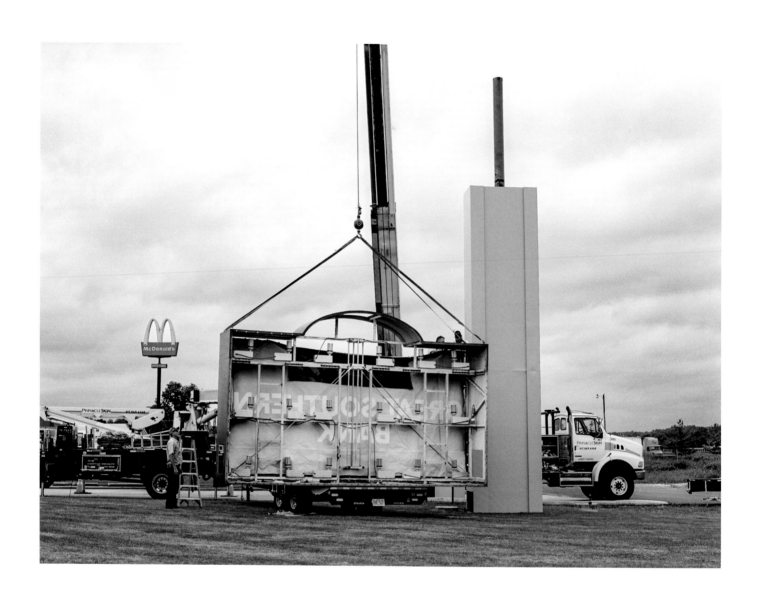

Thursday, 10/4 · New signage for a new bank, Mountain View, Missouri.

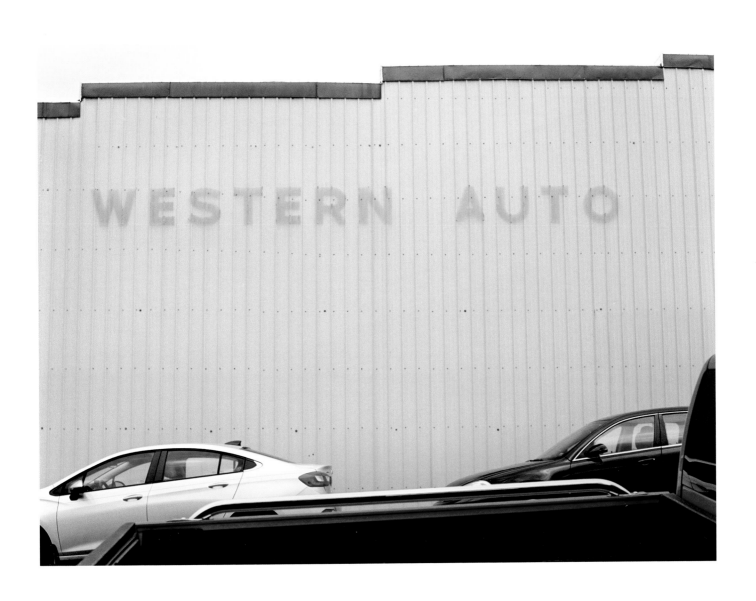

Thursday, 10/4 · Mountain View, Missouri.

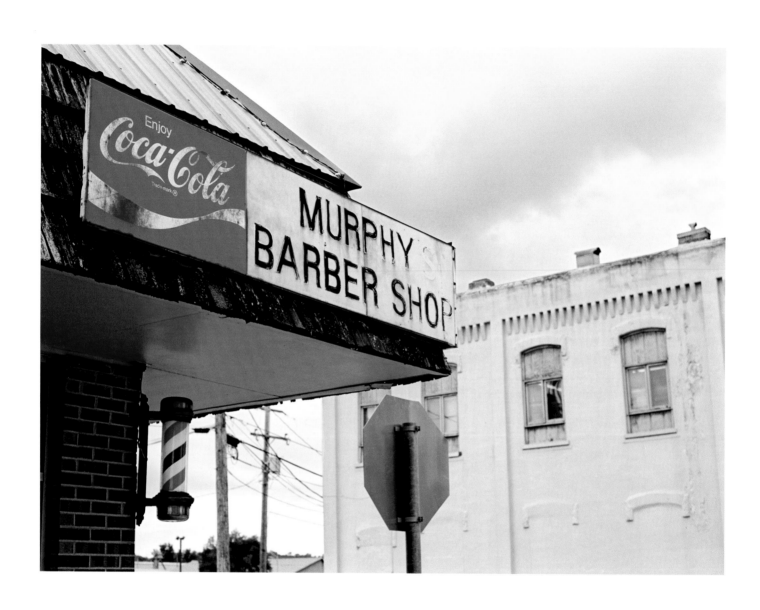

Thursday, 10/4 · Mountain View, Missouri.

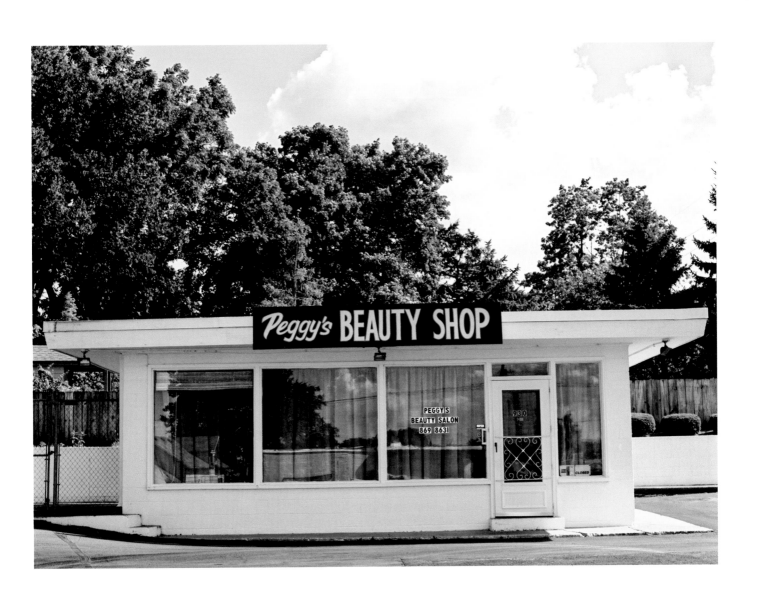

Thursday, 10/4 · Route 66, Springfield, Missouri.

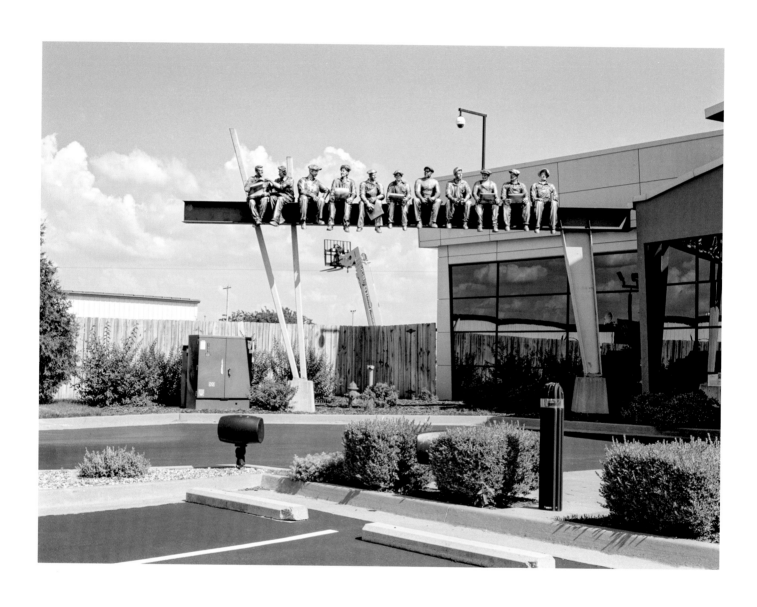

Thursday, 10/4 · Nostalgic replica at a corporate headquarters, Springfield, Missouri.

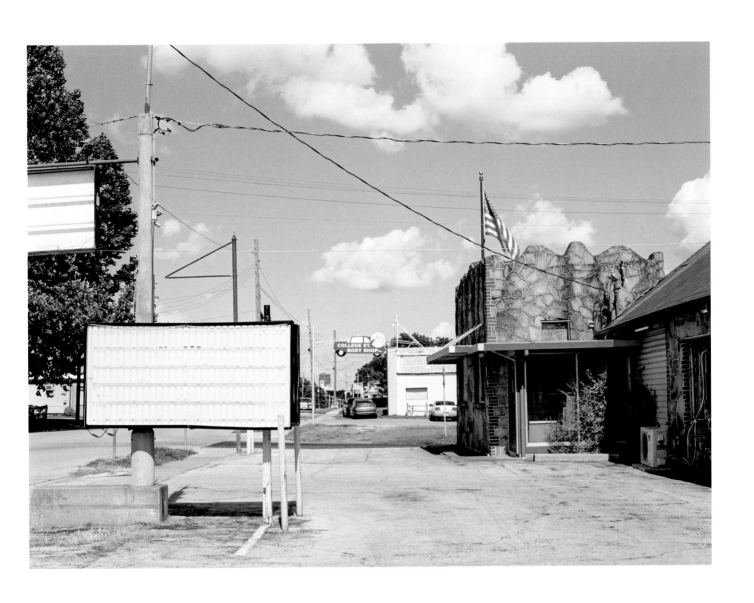

Thursday, 10/4 · Fieldstone building, Route 66, Springfield, Missouri.

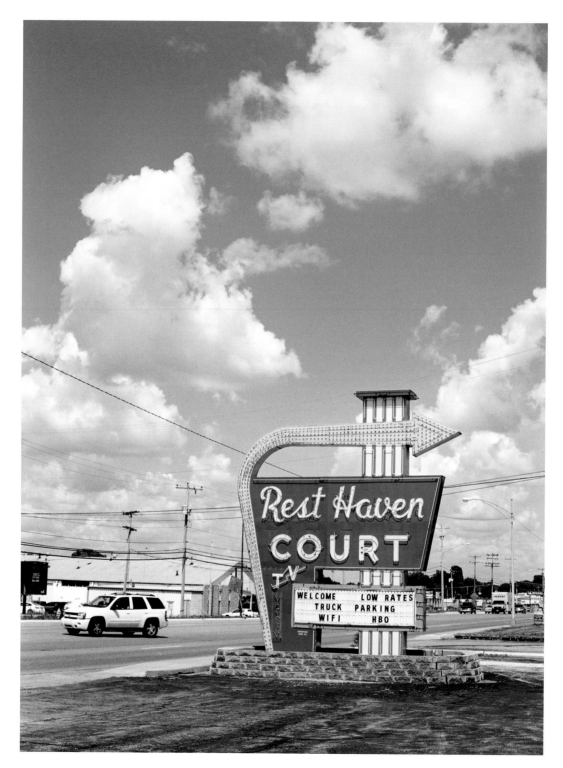

Thursday, 10/4 · Restored signage, Route 66, Springfield, Missouri.

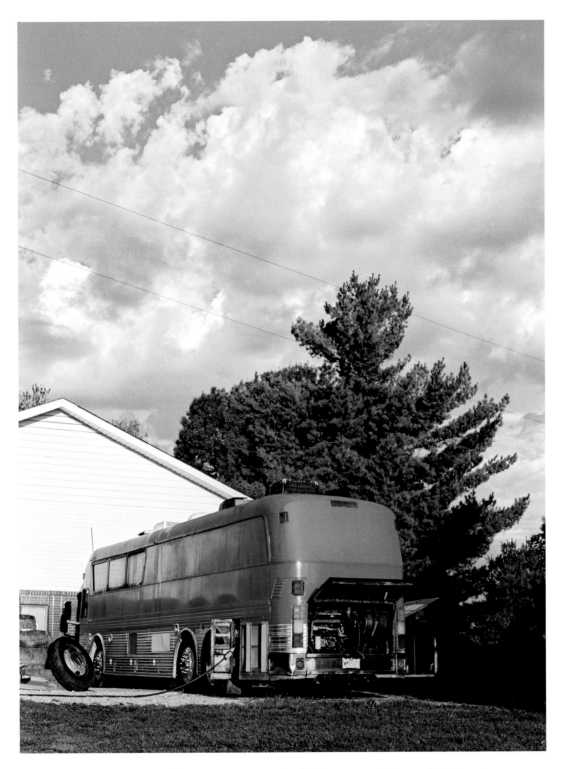

Thursday, 10/4 · Brother Scott's vintage tour bus (under restoration), Rogersville, Missouri.

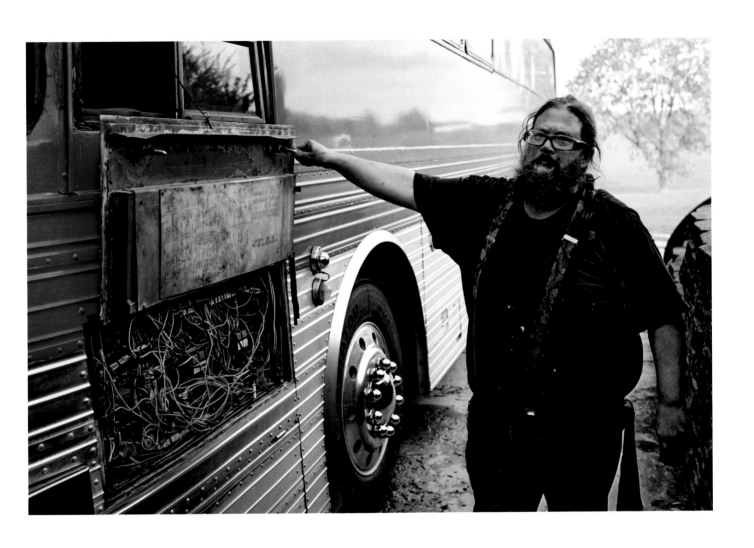

Thursday, 10/4 · Brother Scott, Rogersville, Missouri.

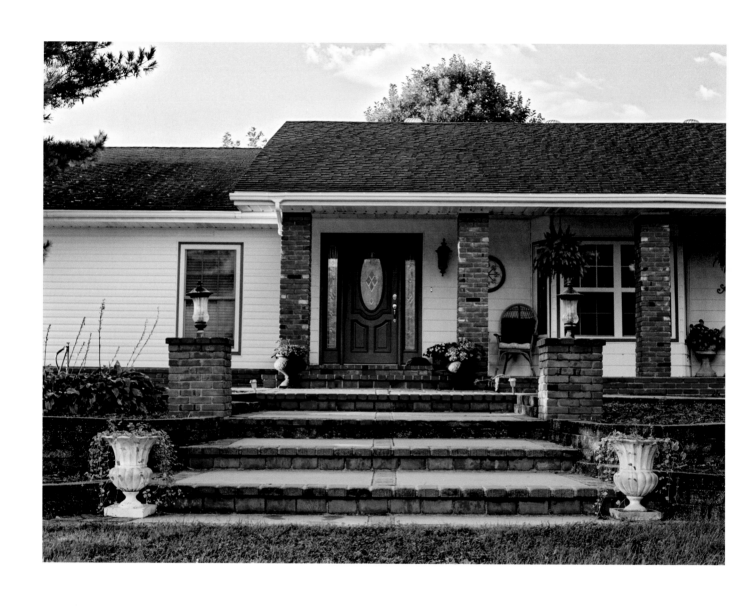

Thursday, 10/4 · Phipps's home, Rogersville, Missouri.

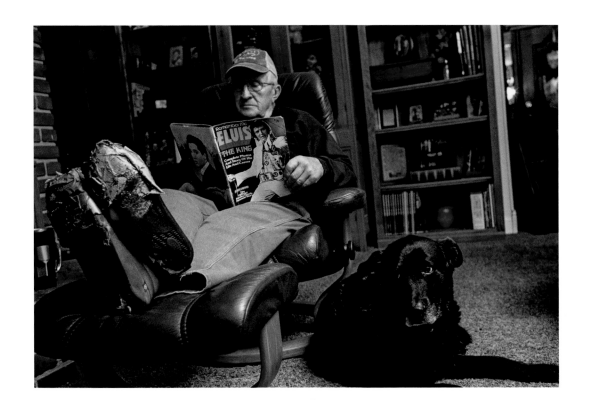

Thursday, 10/4 · Dad with souvenir, sitting in Uncle Dick's former chair, Rogersville, Missouri.

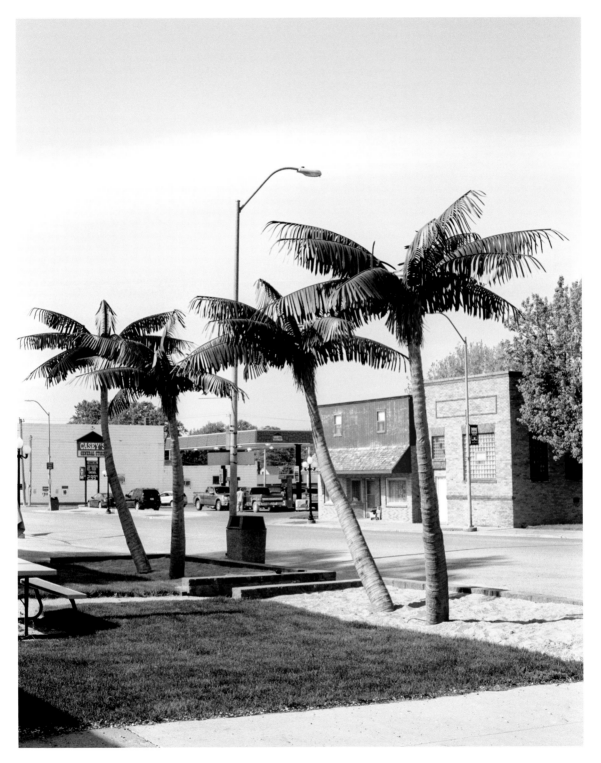

Friday, 10/12 · Plastic palm trees, Maxwell, Iowa.

During one of our many car conversations, Mom shared that she had asked Dad the previous Christmas if he wanted new slippers, and that he had said no, that his slippers were completely fine. By February, his slippers had fallen apart so my parents had gone into town to buy new ones. It turns out that you can only buy slippers at Christmastime, so Dad just duct-taped the soles back together and called it good. It's not that Dad can't afford new slippers, but that buying slippers is more of a seasonal thing and Mom couldn't just order some online because most slippers make Dad's feet too hot or they are too fuzzy. So the decision was made to wait until stores stocked slippers again, and when Dad could try them on himself.

Later during our drive, on the side of an old brick building in Walnut Ridge, Arkansas, I saw a strange mural of a haloed guitar man who appeared to be floating in a lonely ether of luminous blue. He didn't particularly look like anyone famous; perhaps he was a local man. I asked Mom to pull over and I ran across the busy street, backed up as far as I could without getting run over, and took a photo. Looking at it later, I realized that he was all that remained of a larger mural of an entire band that had been covered over with a new coat of paint. His halo was, in fact, the remaining background from the former painting. Why was he spared, while his bandmates succumbed to oblivion?

Toward the end of the trip, while driving on Route 66 through Strafford, Missouri, we passed some guys doing construction on a new gas station that looked like an old retro station in classic adobe-style from the 1940s. They were hoping it would be a draw to bring tourism to the amputated stretch of bypassed Main Street. I had photographed a gas station just like it a few hours before in Thayer, Missouri. I wondered if I would have made the connection had I not seen the one earlier. The "gas station" in Thayer had a sign indicating it was a muffler shop, but it might have actually just been some guy using it as a place to work on cars.

The morning after I returned to Iowa City, I was fumbling around in the kitchen trying to make coffee, and I knocked a glass container off the counter. The jar survived but landed on our dustpan and busted off the handle. I tried to use the dustpan as best I could to sweep up my mess, and in doing so I noticed how old it had become. The plastic was completely brittle and yellowed. We'd had it for so long that I couldn't

remember not having it. I realized it was something that I use almost every day but hadn't ever bothered to really look at. I wondered why I am drawn to photographing things in the outside world that I have less connection to, while filtering out something I've possessed for years, something old that I have made do with despite its aged state.

I joined Mom on this trip mostly to spend some time together and to help with the driving, but also because I wanted to photograph the mysterious and alluring South. I had been photographing Iowa exclusively for six years and wanted to know how a small town in Mississippi or Georgia was similar or different from one in the Midwest. I wanted to experience the subtle shifts that happen when one travels through geographic and cultural regions. I was surprised to discover that not as much changed as I had anticipated. Small towns in the South look a lot like towns in Iowa.

When I travel through new places, my hope is to have an authentic regional experience. I try to find things to compose that describe that place in time, always concerned that perhaps I've shown up a little too late, that the essence has been scrubbed clean and replaced with a nostalgic replica. And really, what business do I have trying to express the essence of the South? I'm a fifty-one-year-old man from Iowa, just passing through with his mom, taking a table to his Aunt Diane. In retrospect, it was our conversations and Mom's recollections from the trip, written in a red spiral notebook, that seem most authentic to me.

If you ask me what this collection is about, I'll likely say something about what it means to be "just passing through" a landscape defined through layers of cultural accumulation, of the present never being uniformly present tense, of the commodity and function of nostalgia, of post and past tourism, of winners and losers, reconstructions, of heightened awareness sandwiched between the comfort of routine, of what is destroyed, changed, salvaged, mined, or pounced upon . . . and what is spared. Like taped-up slippers or a lone guitarist or a reconstructed vintage gas station or a yellowed dustpan.

My hope is to present a momentary description of an America in flux; a country that holds on to the comforts of the past while facing an uncertain future.

Barry Phipps · Iowa City, Iowa · May 2020

a nearby bldg was where they
recorded their records. They was
from Macon. We had Southern
Sole food or comfort food. Barry
had ~~BBQ~~ Fried Chicken + Collard greens. I
had BBQ Brisket + Okra. The okra
was as usual not burned to my
liking. Barry bought T-Shirts
for him + Giselle.

Sat. 30th 29th
 Left Troy heading for Diane's
by supper time. Did some stopping
for pictures along the way. Was
surprised by the scenery in Fl.
Lots of Pine tree's and other types
of trees. Including a + gre of
oak tree w/ moss hanging from it.
Kept looking for alligators. Never
saw one. Got to Diane's after
dark. Tim over and Diane made
pasta for supper.

Sun 30st
 Tim + Barry Spent the day together
taking pictures. Diane + I went
to an Ikea store. ~~We met Barry
at the Ringling Bros. Museum. After
walking around the grounds + taking
some pictures~~